ASIAN
ILLUSTRATION

46 Asian illustrators
with distinctively sensitive
and expressive styles

目次　Contents

ASIAN ILLUSTRATION

PIE International Inc.
2-32-4 Minami-Otsuka, Toshima-ku, Tokyo 170-0005 JAPAN
international@pie.co.jp

ISBN978-4-7562-5340-8 (Outside Japan) Printed in Japan

006	GUWEIZ	GUWEIZ	SG	120	咸鱼中下游	Blaine Zhou	CN
016	李超雄	arxlee	CN	124	REDUM	REDUM	CN
020	PainDude	PainDude	TW	130	sheya	sheya	CN
026	성률	SEONG RYUL	KR	134	邦乔彦	bangqiaoyan	CN
030	먹는빵	Bakery00	KR	138	口袋巧克力	Pocket Chocolate	CN
034	白川柏川	baichuan	CN	142	王小洋	Wang Xiaoyang	CN
038	叶鸦	kara xu	CN	146	李彬	Bin Lee	CN
042	아롱	Ahrong	KR	150	北桥泽	BeiQiaoZe	CN
046	inplick	inplick	KR	152	苏小五	Litfive	CN
050	NJ	NJ	KR	154	切尸红人魔	Seven	CN
054	인혜	VIVINOS / INH	KR	162	低級失誤	Saitemiss	TW
062	RIRIFA	RIRIFA	CN	166	meyoco	meyoco	ID
066	Sainker	Sainker	CN	170	M-Y 蚂蚁	M.Y	CN
072	幻電放映	electroillusion	CN	174	나무 13	TREE13	KR
078	illumi	illumi	CN	180	정현	Jeonghyeon	KR
082	孙无力	sunwuli	CN	184	알페	Alle Page	KR
088	grandia 元	grandia	CN	188	年年	niannian	CN
092	GHARLIERA	GHARLIERA	KR	192	羅雨時	luoyushi	CN
096	Novelance	Novelance	CN	194	法吉特	forget	CN
102	纹银	Ming	CN	198	何何舞	Eno.	CN
106	FKEY	FKEY	CN	202	飞行猴	Chen Feng	CN
110	NoriZC	NoriZC	CN	206	LOIZA	LOIZA	TW
116	俊西 JUNC	WENJUN LIN	CN	212	Zeen Chin	Zeen Chin	MY

活動拠点略字｜Activity Base Abbreviations　※以下、アルファベット順 *in alphabetical order

China = CN　Indonesia = ID　Korea = KR　Malaysia = MY　Singapore = SG　Taiwan = TW

本書の見方　Notes on Book Layout

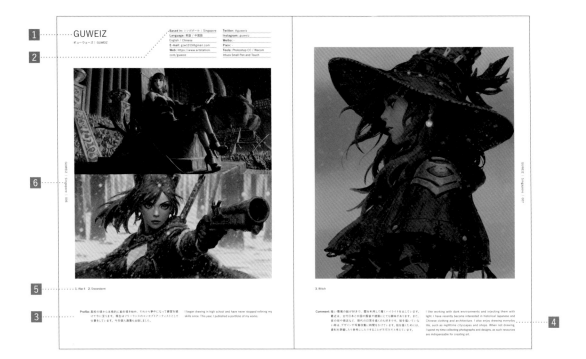

1. 作家名
主な活動名義 / 主な活動名義カナ / 英語名義 の順に記載しています。

2. 基本情報
Based in ＝活動拠点
Language ＝対応言語
E-mail ＝メールアドレス
Web ＝ホームページアドレス（URL）
Twitter ＝ Twitter ID
Instagram ＝ Instagram ID
Weibo ＝ Weibo ドメイン名（@ユーザー名）
※ドメイン名が未設定の場合は数字を記載しています。
※ドメイン名・数字で検索する際は、先頭に weibo.com/ をつけてください。
※ app 内ではユーザー名で検索してください。
Pixiv ＝ Pixiv ID
※ ID 検索の際は、先頭に pixiv.net/users/ をつけてください。
Tools ＝制作ツール

3. 作家プロフィール

4. 創作についてのこだわりやアピールポイントなどのコメント

5. 作品タイトル
母国語のタイトルを日本語と英語に翻訳しています。
ただし、タイトルが元々英語でつけられている場合は、そのまま英語だけ記載しています。

6. Index
作家名 / 活動拠点 / ページ数

※掲載作家の意向により、情報の一部を記載していない場合があります。
※掲載情報は、2020年7月現在のものです。予告なく変更される場合があります。
　あらかじめご了承ください。
※各企業名に付随する株式会社・有限会社等の法人格の表記は省略しております。
※本書の掲載作品は全て著作権法で保護される著作物です。コピーライト表記の
　有無にかかわらず、権利者に無断で複製・複写・転載・改ざんをすることを固
　く禁じます。
※本書に掲載された企業名・商品名は、掲載各社の商標または登録商標です。

1. Artist Name
Listed in order of: Main pen name / Japanese pronunciation / English pen name

2. Artist Information
Based in: location of artist's main activities
Language: languages used by artist for work
E-mail: e-mail address
Web: website address (URL)
Twitter: Twitter ID
Instagram: Instagram ID
Weibo: Weibo domain name (@user name)
*Account is indicated with a number if Weibo domain name is not yet set up.
*For Weibo searches: always add weibo.com/ in front of the domain name or number.
*When searching within the app, use the user name.
Pixiv: Pixiv ID
*For ID searches: always add pixiv.net/users/ in front of the ID.
Tools: artistic tools used by the artist

3. Artist Profile

4. Artist Comments: creative methods, influences and aspirations

5. Artwork Titles
Original titles are translated into Japanese and English.
When the original title is in English, only English is provided.

6. Index
Artist Name / Artist's Production Base / Page Number

* Some information has been omitted, per the artist's request.
* The information noted above is current as of July 2020, and may change
 without prior notice.
* The official corporate names of companies acknowledged here have been
 abbreviated.
* All works listed in this publication remain protected by copyright law. All
 rights reserved, including the right to reproduce this work or portions
 thereof in any manner without prior permission, even where the copyright
 mark has not been indicated on a particular work or publication.
* The company and product names that appear in this book are published
 and/or registered trademarks.

ASIAN ILLUSTRATION

GUWEIZ

ギューウェーズ｜GUWEIZ

Based in: シンガポール｜Singapore
Language: 英語／中国語
English / Chinese
E-mail: gzw1019@gmail.com
Web: https://www.artstation.com/guweiz

Twitter: ttguweiz
Instagram: guweiz
Weibo: -
Pixiv: -
Tools: Photoshop CC / Wacom
Intuos Small Pen and Touch

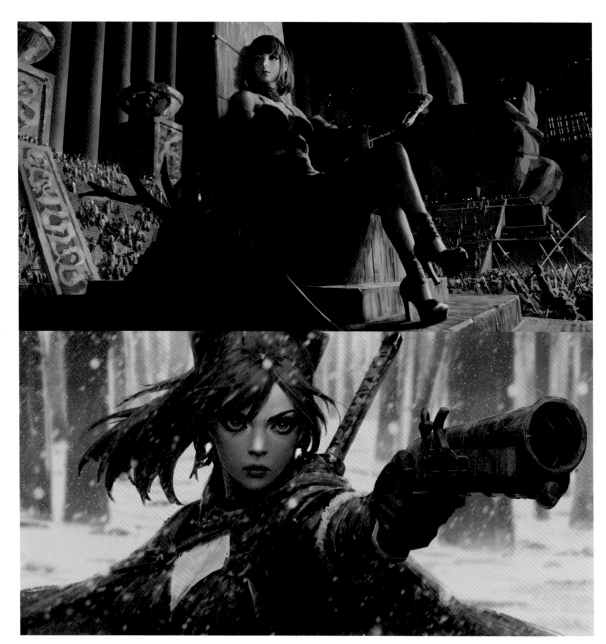

1. War 4 **2.** Snowstorm

Profile: 高校の頃から本格的に絵を描き始め、それから夢中になって練習を続けて今に至ります。現在はフリーランスのコンセプトアーティストとして仕事をしています。今年個人画集も出版しました。

I began drawing in high school and have never stopped refining my skills since. This year, I published a portfolio of my works.

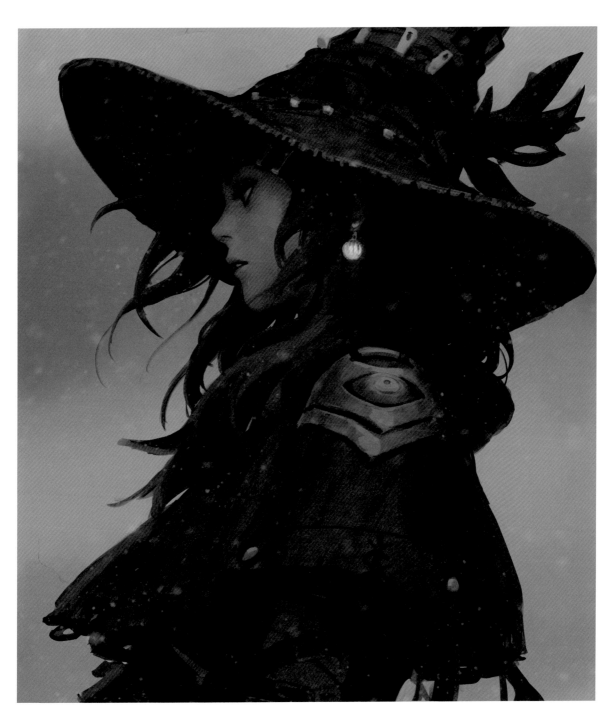

3. Witch

Comment: 暗い環境の絵が好きで、闇を利用して輝くハイライトを出しています。最近は、古代日本と中国の服装や建築にとても興味があります。また、夜の街や商店など、現代の日常を描くのも好きです。絵を描いていない時は、デザインや写真収集に時間をかけています。絵を描くためには、資料を準備したり参考にしたりすることが不可欠だと考えています。

I like working with dark environments and injecting them with light. I have recently become interested in historical Japanese and Chinese clothing and architecture. I also enjoy drawing everyday life, such as nighttime cityscapes and shops. When not drawing, I spend my time collecting photographs and designs, as such resources are indispensable for creating art.

4. War 2.5

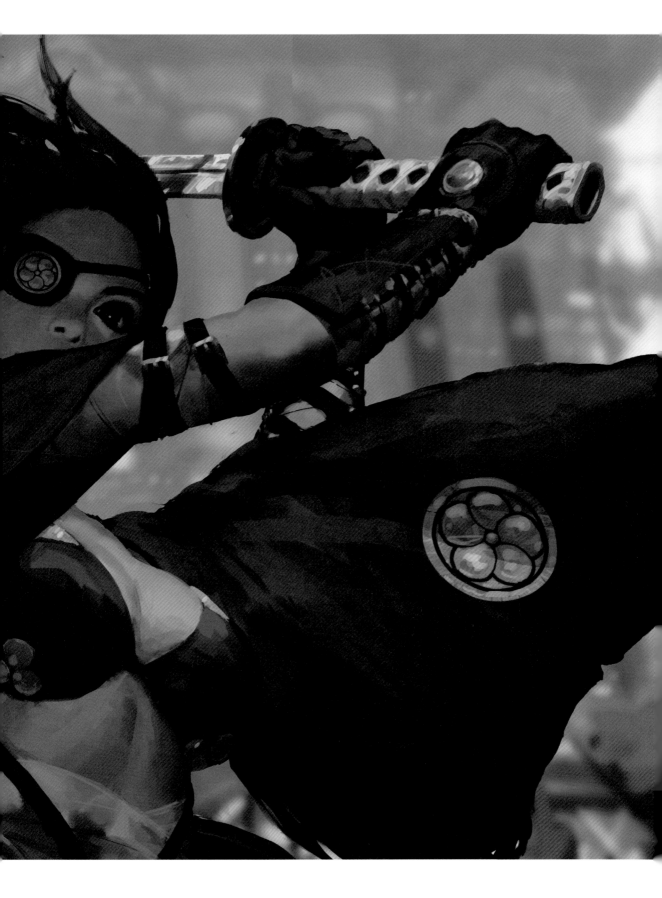

5. Train Stop

6. Woods

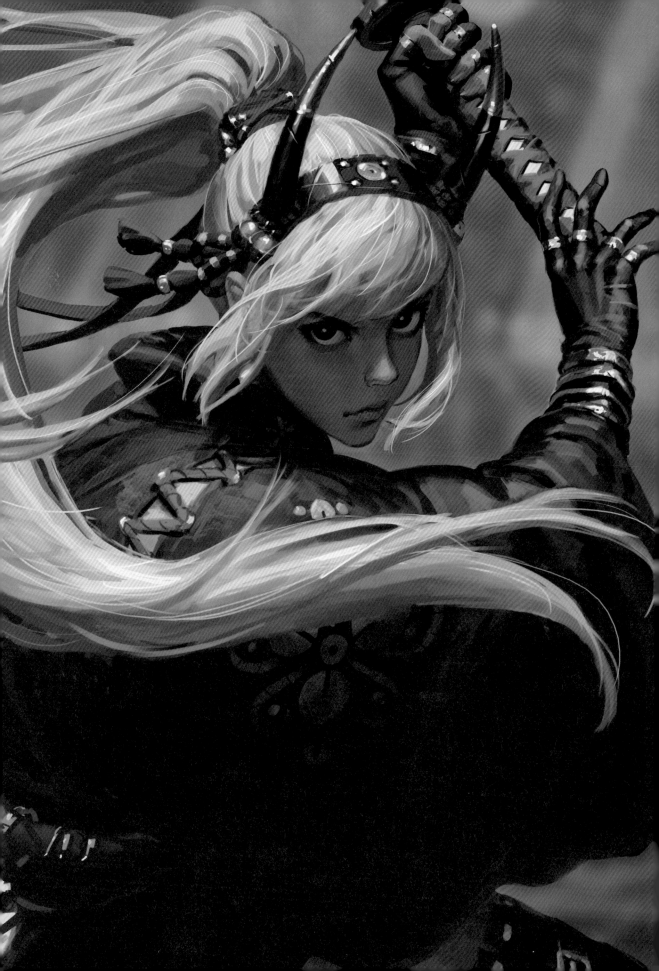

Cover Illustration

戦闘 *Battle* by GUWEIZ

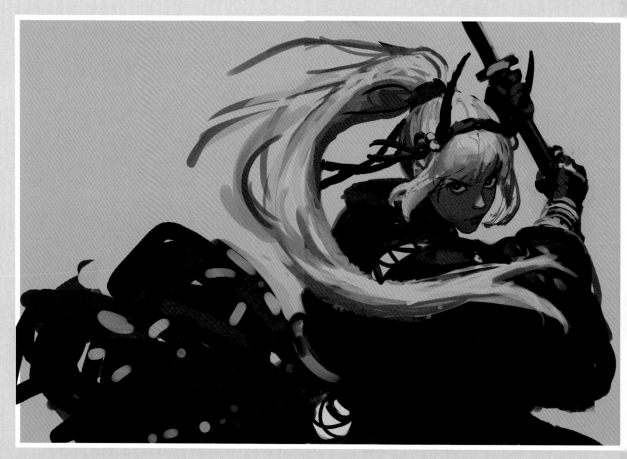

戦闘（ラフスケッチ）| Battle（rough sketch）

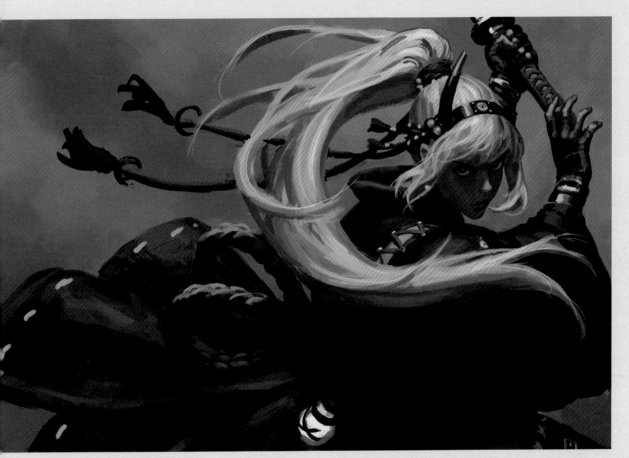

戦闘（着彩過程）| Battle（coloring process）

Comment

今回の絵は、表紙と裏表紙のフォーマットに合わせるため、初めてチャレンジした構図です。依頼のポイントは、躍動感やインパクトなどで、特にそれが表紙として表現されていることが必要でした。なので、半分の絵の状態でも、ちゃんと表紙としての躍動感やデザイン性があるかどうかをマメに確認していました。大きなチャレンジになりました！キャラクターについては、わりと描き慣れたデザインにしました。構図の経験不足をこれで補えたらいいなと思っています。皆様に気に入っていただけたら嬉しいです！

This was the first time I had to tailor an image so that it worked as a wraparound cover. In particular, I was requested to make sure the front cover was dynamic and striking. I worked hard to position the design so that the most vigorous and sophisticated elements appear on the front. What a challenge that was! I chose a character that I have drawn in the past, which I hope compensates for my inexperience in designing book covers. I truly hope everyone enjoys what I have created!

李超雄

リ・チャオシォン｜arxlee

Based in: 中国｜China
Language: 中国語｜Chinese
E-mail: 853672356@qq.com
Web: -

Twitter: -
Instagram: -
Weibo: arxlee（@超雄 arxlee）
Pixiv: -
Tools: アクリル／油絵具｜acrylics／oil paints

1. OK 扉｜OK Door

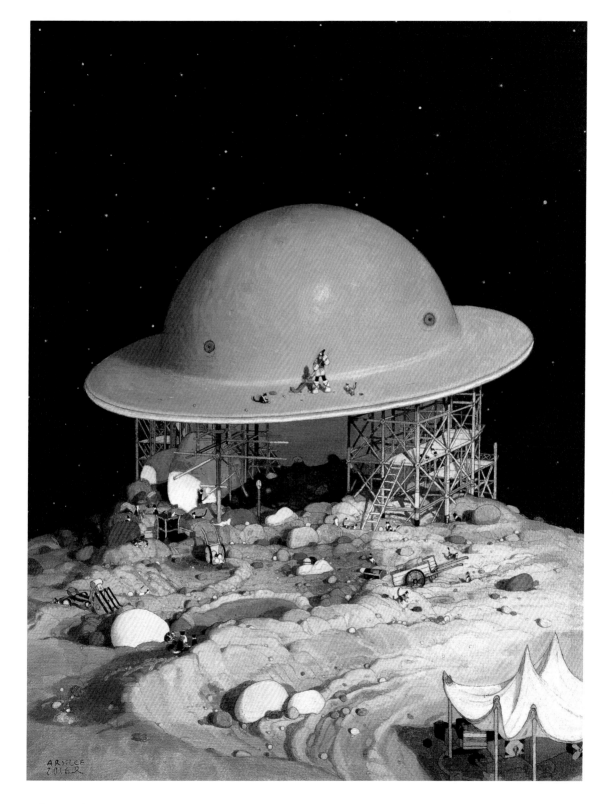

2. 陽昇リワーク | Off to Work at Sunrise

Profile: 1978年8月広東省中山市生まれ。2002年に広州美術学院油絵学科を卒業。代表的な展示は、2017年個展「"Fantastiques" Philippe Druillet invites Arx Lee」（LOFTギャラリー／パリ）、2018年個展「尋・快楽の夢行者」（達園芸術館 / 広州）など。他グループ展を多数開催しています。

Born in August 1978 in Canton, I graduated from the Guangzhou Academy of Fine Arts in 2002, majoring in oil painting. I have exhibited in many solo and group shows, including "Fantastiques" Philippe Druillet invites Arx Lee (Paris, 2017) and Phantom/Pleasure Dreamer (Guangzhou, 2018).

Comment: 絵に登場するブミとキちゃん。ブミはサンスクリット語で「大地」を意味します。この二人のキャラクターは少し宗教的です。ブミの目を閉じる設定は「ここは誰かの夢の中」であることを表します。目を閉じた彼は心で世界を感じ、夢の中を歩く小さな僧侶のようです。目的は夢の外の彼を癒すこと。夢は心の世界と繋がります。このテーマは5年続けました。時期によって紙にアクリル、キャンバスに油彩で描いています。

My illustrations feature Bumi (Sanskrit for "the earth") and Little Ki, somewhat spiritual characters. With his eyes closed, Bumi is like a little monk who dream walks, sensing the world in his heart as he strives to soothe his waking-life soul. Bumi's dreams seem to connect his heart to the world. I have been working with these characters for 5 years, sometimes using acrylics and sometimes oil on canvas.

3	4
5	6

3. 前へ行く｜Going Forward　**4.** 星の快速列車｜Star Express Train　**5.** 休憩｜Break Time　**6.** 小さな正方体｜Small Square

PainDude

ペインジュード｜PainDude

Based in: 台湾｜Taiwan
Language: 中国語｜Chinese
E-mail: a97185146@gmail.com
Web: https://www.artstation.com/paindude

Twitter: PainDude_Wu
Instagram: -
Weibo: 6363265622 (@Paindude_)
Pixiv: 2820772
Tools: Photoshop CC 2019

1. 半夢半醒の間｜Half-dreaming, Half Awake　2. 探す｜Search

Profile: 台湾芸術大学を卒業。自分の作品は、二人の偉大なアーティスト、サージェントおよびクレイグ・マリンズの影響を深く受けています。相反するものが好きで、欧米の油彩画と日本の画法を勉強し、二つの画法を組み合わせて表現することに挑戦しています。

I graduated from the National Taiwan University of Arts. My work is influenced by two great artists—John Singer Sargent and Craig Mullins. I like to see conflict in art. I studied Western oil and Japanese-style painting, challenging myself to create works integrating the two styles.

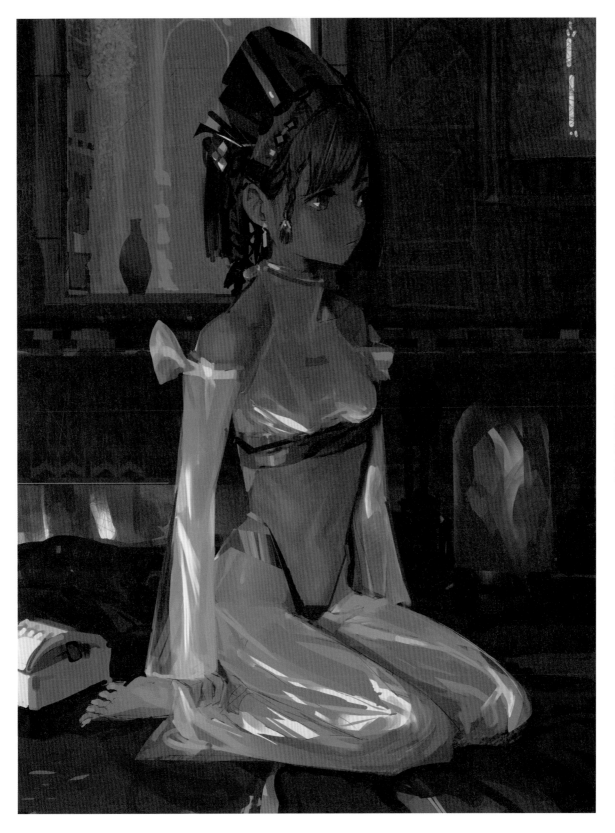

3. 彼女 | Her

4. 半夢半醒の間 | Half-dreaming, Half Awake

5	7
6	8

5. 6. 7. 8. 半夢半醒の間｜Half-dreaming, Half Awake

Comment: 物語が好きで、絵を描くのも好きです。鑑賞する人が絵を観て、自分独自の解釈を持ってくれるといいなと思います。創作をする時は、音楽を聴くのが好きで、気の赴くまま音楽を自分の想像に取り入れて、画面に表現しています。「半夢半醒の間」シリーズの創作は現在進行中です。どんなものでも、曖昧なものを表現したいと思っています。自分の作品が皆さんに気に入ってもらえて、共鳴しあえたら最高です。

I love narrative as much as imagery. I hope people interpret my works in their own way. During the creative process, I let music nurture my imagination while I paint. Right now, I am working on the Half-dreaming, Half Awake series. I try to imbue whatever I create with mystery. Hopefully, my art will please and resonate with everyone.

성률

ソンリュル | SEONG RYUL

Based in: 韓国 | Korea
Language: 韓国語 / 英語 / 日本語
Korean / English / Japanese
E-mail: sseongryul@gmail.com
Web: -

Twitter: seong_ryul
Instagram: sseongryul
Weibo: -
Pixiv: -
Tools: 透明水彩 | transparent watercolors

Profile: 韓国芸術総合学校でアニメーションと漫画を学び、卒業後、ソウルでイラストレーター・漫画家として活動しています。独立出版で漫画『in summer』『Panorama』を出版し、今後も本を出し続けていくことを目標にしています。

Since graduating from the Korea National University of Arts with a focus on animation and manga, I been working as an illustrator and manga artist in Seoul. With two self-published manga works to date (*in summer* and *Panorama*), I aim to continue creating manga books in the future.

1. 2. 3. 夏に | in summer

Comment: 時と季節の移り変わりによって変化する光の色に興味を持っています。季節が変われば、空や木の色も変化します。反映した影の色も、時が経つにつれて変化します。そのような様々な変化を捉え、絵に描くことがとても好きです。

I am interested in the colors of light as they change with the hours of the day and the seasons. Different seasons boast skies and trees of various hues. The colors of shadows also change with passing time. I enjoy capturing every change and putting them on paper.

4. 夏に｜in summer

5. 夏に │ in summer

먹는빵

モッヌンパン｜Bakery00

Based in: 韓国｜Korea
Language: 韓国語｜Korean
E-mail: zzinp70@naver.com
Web: https://bakery09.tumblr.com/
Twitter: Bakery00

Instagram: sion.dang
Weibo: -
Pixiv: -
Tools: Photoshop CC / Adobe Fresco / Procreate / 水彩｜watercolors

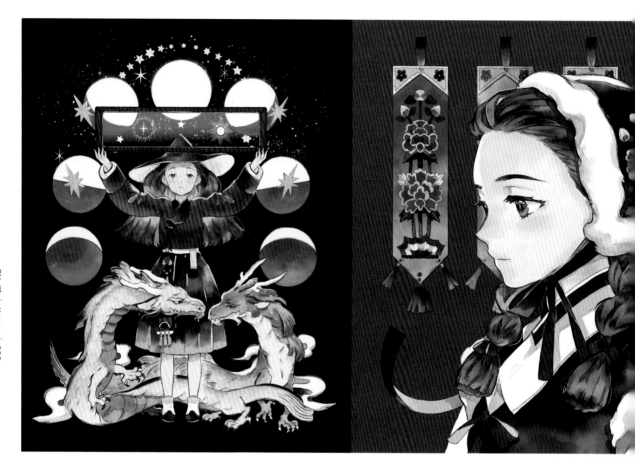

1. 赤い額縁｜Red Picture Frame　2. 繍装飾少女｜Embroidery Girl

Profile: 絵は独学です。最初はデジタルで水彩風の絵を描いていましたが、今では実際に水彩画を描けるようになりました。現在は主にゲームイラストやウェブ小説のイラストを制作しています。最近ではソウル近郊のカフェで個展も開きました。

I am a self-taught artist. I first digitally simulated a watercolor style, but now use actual watercolors in my work. I mostly draw illustrations for games and web novels, and recently exhibited at a café in the suburbs of Seoul.

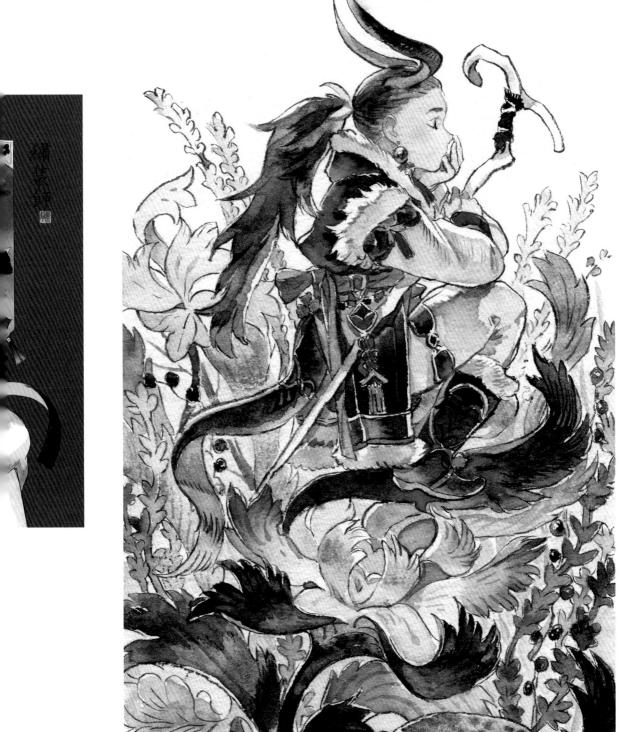

3. 媖想│Recollections

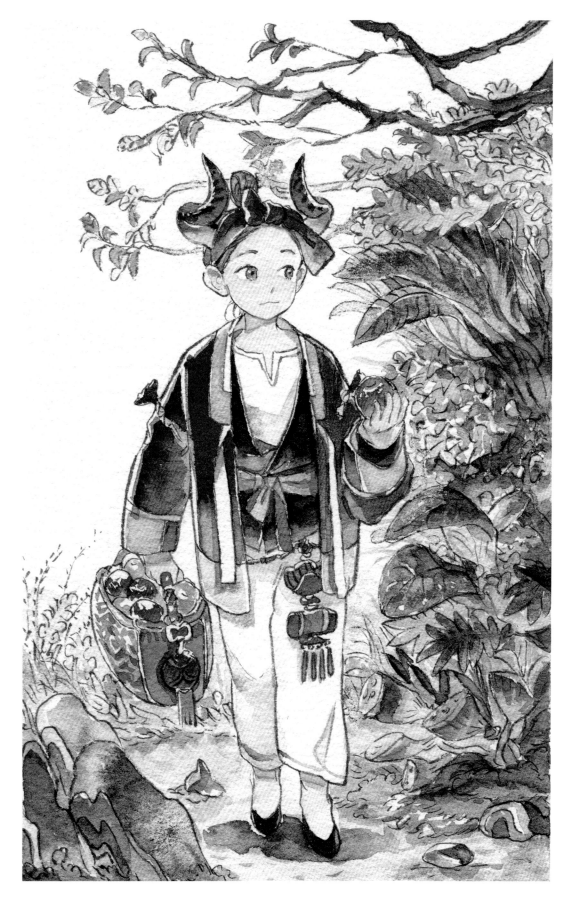

4. 紅玉が熟す季節 | Season of Ripe Red Apples

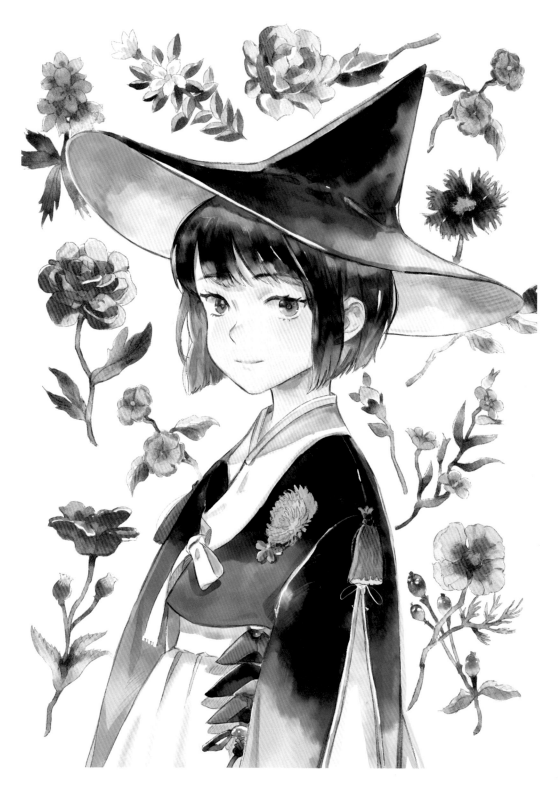

5. 魔女と花 | Witch and Flowers

Comment: 温かみのある独自の東洋風世界観を描いています。ファンタジー性のある人物の様々なお話や状況を描くのがとても好きで、韓国の伝統画や伝統衣装から着想を得て制作しています。そして様々なフュージョンファッションを取り入れたり、ファンタジー的な解釈を入れて、毎年多種多様なテーマで創作しています。制作はデジタル作業とアナログ作業（水彩）を並行しています。

I work from a uniquely heartwarming Asian perspective. Inspired by traditional Korean paintings and costumes, my fantastical characters exist in elaborate situations. Each year I come up with new themes, combining fusion fashion with fantasy interpretations of the world. I create both digital and analog (watercolor) works.

白川柏川

バイチュアン｜baichuan

Based in: 中国｜China
Language: 中国語｜Chinese
E-mail: 739625936@qq.com
Web: -

Twitter: iotaectoplasm
Instagram: -
Weibo: 5888905454（@白川柏川）
Pixiv: -
Tools: Photoshop CS6

白川柏川｜China｜034

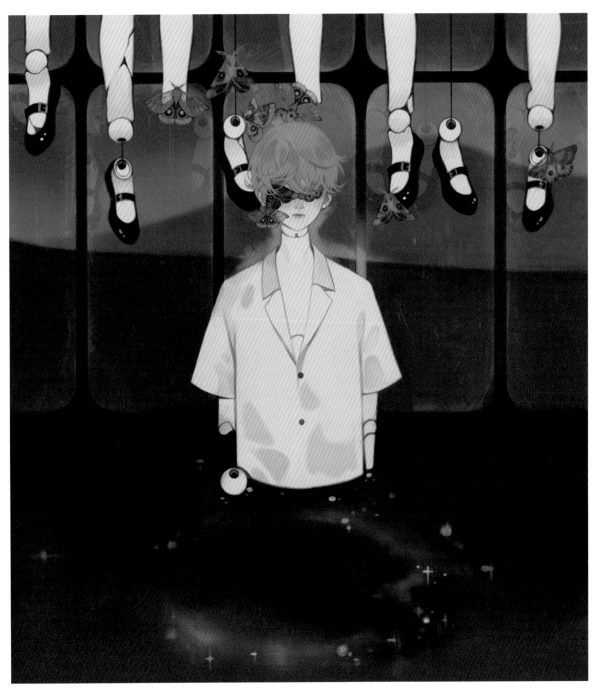

1. 楽園｜Paradise

2. 五｜Five 3. 栖（す）｜Hideaway

Profile: ゲームのプロモーションイラスト、クリエイティブ分野周辺の仕事を中心にしています。

I work mainly creating promotional illustrations for video games and in other creative fields.

ROBIN
A small brown European
bird with a red breast

BUTTERFLY

Most of the butterflies perish in
the first frosts of autumn.

4. アップル｜Apple　**5.** ウサギ｜Rabbit

Comment: 油絵と人形の影響を受け、人を描くことにいつも関心があります。

Heavily influenced by oil paintings and dolls, I have always been interested in drawing people.

叶鸦

イエヤ | kara xu

Based in: 中国 | China
Language: 中国語 / 英語
Chinese / English
E-mail: karaxu328@gmail.com
Web: https://karaxu328.wixsite.
com/heliumraven

Twitter: Helium_Raven
Instagram: helium__raven
Weibo: krowl（@叶_鸦）
Pixiv: -
Tools: Photoshop

Profile: 中学からデジタルで絵を学び始めました。暗い色の中の微妙な変化を探求するのが好きでしたが、最近は伝わりやすい絵を描きたいと思っています。個人画集のため過去の作品を見返したら、自分の変化に驚きました。今後はもっと色々なテーマに挑戦したいと思います。

I started learning digital art in junior high. I used to like exploring the subtleties of darker colors, but now create sunnier images. Upon reviewing my past work while putting together a portfolio for publication, I was surprised by how much my work has changed. I look forward to expanding my range of themes.

| 1 | 2 | 3 |

1. ウリエル | Uriel　2. ミカエル | Michael　3. ガブリエル | Gabrielle

Comment: 神話や伝説、ダークな童話のテーマにずっと興味がありましたが、ロック・ミュージックにハマったら、色使いが豊かになり、ポップアート等のポスターにも影響を受けました。最近は浮世絵に夢中で、古来の着想を絵に取り入れたいと思っています。一貫しているものは、リアルの排除です。リアルを誇張したり逆転させたりするのが好きで、絵は自分にとって現実からの避難所のような存在です。

I used to focus on myths, legends, and dark fairy tales, but shifted to a brighter palette of colors once I got into rock music and Pop Art posters. The world of ukiyo-e is my muse now, and I hope to work the creative ideas of the ancients into my work. The constant element in my art is the exclusion of reality. My refuge from reality, art offers the joy of exaggerating and overturning real life.

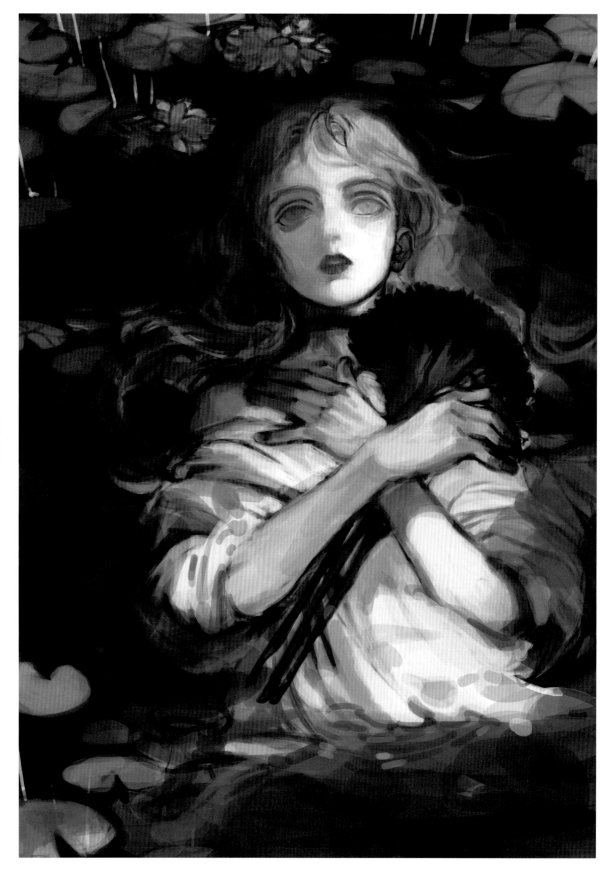

4. オフィーリア | Ophelia

5. 心｜Heart

아롱

アロン │ Ahrong

Based in: 韓国 │ Korea
Language: 韓国語 / 英語
Korean / English
E-mail: eriol_s2@naver.com
Web: -

Twitter: eriol_s2
Instagram: eriol_s2
Weibo: -
Pixiv: -
Tools: Photoshop CC

Profile: 絵は独学です。趣味で絵を描いて、個人的にSNSにアップロードしています。漫画、イラスト、アニメーションなど、いろんなジャンルに挑戦しています。

I am a self-taught artist. I draw as a hobby, posting my works on social media. I am exploring manga, illustration, animation, and other genres of picture-making.

1. Oreo Milk 2. Hayley Law 3. Kitty 4. 無題 │ Untitled

5. Starry Night

6. 幼主 | Child Emperor

Comment: ファッションに興味があり、普段からいろんなブランドのルックブックや コレクションを見て、トレンディな絵を描いています。主にユニークな ファッションの女性を描くのが好きで、静的な雰囲気と落ち着いた彩度 の低い色調が、自分の特徴だと思います。将来機会があれば、自分で デザインした衣装を製作してみたいです。

Interested in fashion, I typically draw stylish pictures inspired by the lookbooks and collections of various brands and designers. I especially like drawing women in unique clothing. The hallmarks of my work are quiet atmospheres with subdued tones. One day, I would love to have the chance to design and create my own clothing.

inplick

インプリック｜inplick

Based in: 韓国｜Korea
Language: 韓国語 / 英語 / 日本語
Korean / English / Japanese
E-mail: inplick@naver.com
Web: -

Twitter: inplick
Instagram: inplick
Weibo: INPLICK (@INPLICK_)
Pixiv: -
Tools: CLIP STUDIO PAINT /
Photoshop 2020

1. Elevator　**2.** Milk

3. Jellyfish

Profile: フリーランスのイラストレーター。2015年からアニメーションやイラスト分野に関心を持ち始め、独学で絵を始めました。主にファッション雑誌形態の絵やキッチュな感じのアイテムが入ったパステルトーンの絵など、色々な分野に興味をもって描いています。

I am a freelance illustrator. I became interested in animation and illustration in 2015, and began creating without any art education. I am interested in a wide variety of fields, especially the kinds of images you find in fashion magazines and pastel-colored pictures with kitschy items in them.

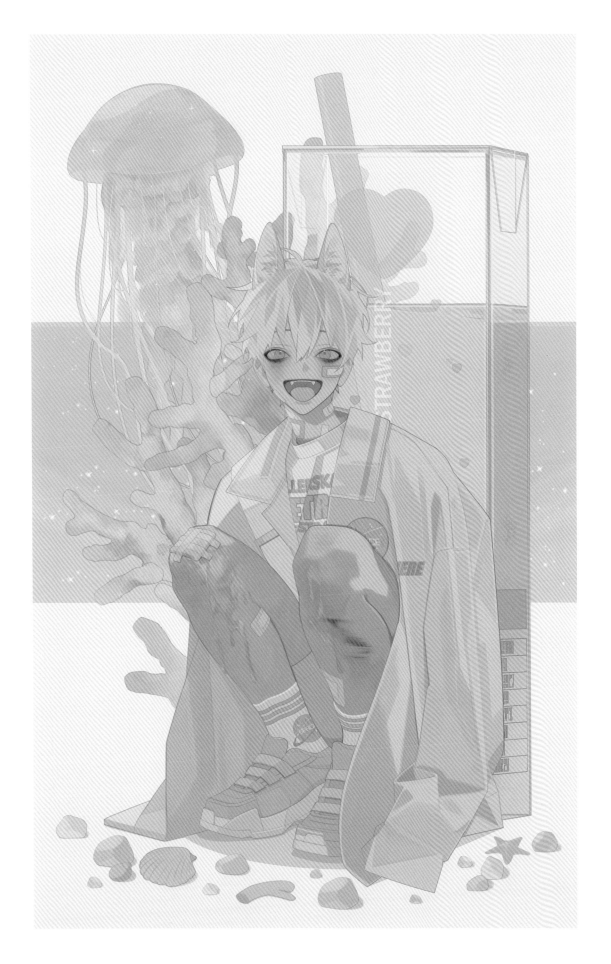

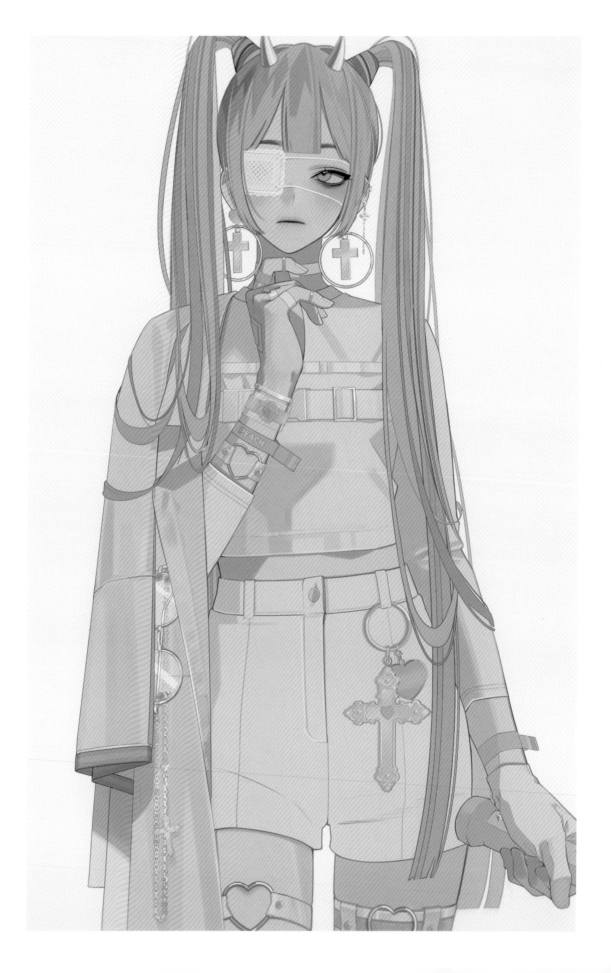

https://twitter.com/inplick

4. MOMO

5. Student Card

Comment: 以前からファッションやパステルトーンのキッチュなもの、雑誌のデザインの雰囲気がとても好きでした。また、少しグロテスクな感じや夢幻的な雰囲気の作品にも強く惹かれ、それらが自分の創作活動に影響を与えて、様々な作品を作ってきました。最近は、これまで描いてきたものとは別のジャンルでも多種多様に表現したいと思っていて、色々なことを試しています。

I have long enjoyed the design of magazines featuring fashion and pastel kitsch. I'm also strongly drawn to somewhat grotesque and dreamlike creations, which have shaped my creative output in various ways. Recently, I have been thinking that I would like to branch out and try new things beyond the genres I have worked in so far.

NJ

エヌジェイ｜NJ

Based: 韓国｜Korea
Language: 韓国語 / 英語 / 日本語
Korean / English / Japanese
E-mail: notjya@gmail.com
Web: -

Twitter: notjya
Instagram: notjya
Weibo: 6132639371 (@Notjya)
Pixiv: -
Tools: Photoshop CC

1. CHANEL

Profile: 定型化された美しさではない、それぞれ個性のある人物を創作するために努力しています。主にゲーム、小説、雑誌、CDジャケットなどで、人物中心のイラストまたはキャラクターデザインを描いています。

I strive to create characters with unique personalities, breaking with fixed standards of beauty. I mainly make illustrations and character designs of human figures for video games, novels, magazines, and CD covers.

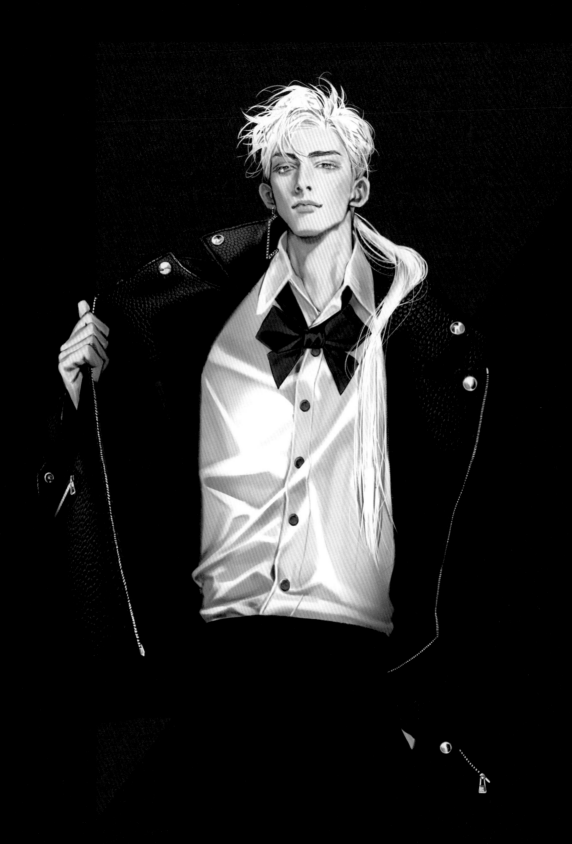

2. V

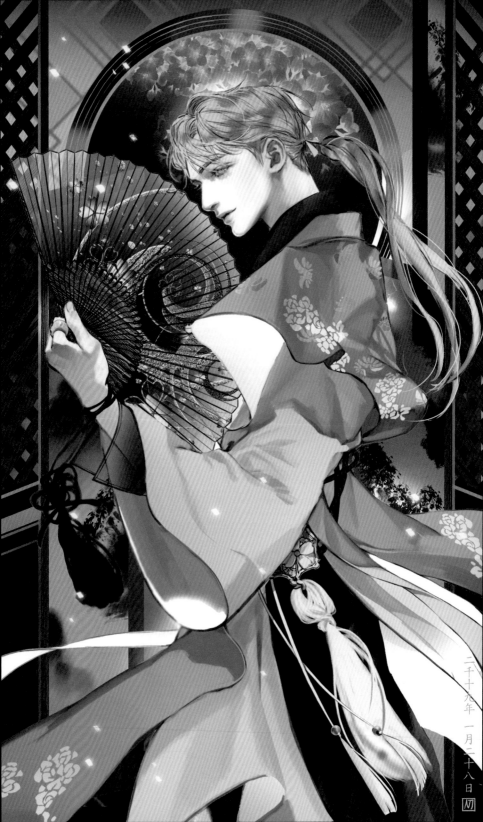
二千十九年 一月二十八日

二千十九年 一月二十八日 [N]

Comment: 美しさにはアイデンティティがあります。みなさんの想像の中にいるような人物と、その人物に存在感を持たせられる演出やモチーフを描くことに力を入れています。

I believe identity exists within beauty. My focus is on drawing the type of characters we all might imagine, along with the actions and motifs that give each character a special presence.

인혜

インヘ｜VIVINOS / INH

Based in: 韓国｜Korea
Language: 韓国語／英語／日本語
Korean / English / Japanese
E-mail: vivinos162@gmail.com
Web: https://www.Inhsy.com/

Twitter: inh__sy
Instagram: vivinos__
Weibo: 6544952664 (@VINOVIS)
Pixiv: 13128008
Tools: CLIP STUDIO PAINT EX /
Photoshop

1. DRUGS

2. Death POP

Profile: イラストは独学です。ゲームグラフィック学院「Brush on」と「Fanding」でワークショップを主宰しています。講師経歴 3 年。現在、ファッション、コスメ、ジュエリーとのコラボレーション、またミュージックビデオ、商品デザインの分野で活動しています。

I am a self-taught illustrator with three years' experience lecturing and organizing workshops at Brush on and Fanding game graphics academies. I currently collaborate on projects in fashion, cosmetics, and jewelry, while also working on music videos and various product designs.

3. Peach Pink

4. Strawberry Time

5. Sweet Alice

6. Love Messenger

Comment: 幼い頃にテレビ番組で見聞きした面白い話を、ピンク色を使って女の子好みのテイストで表現することが好きです。イラストレーションを中心にフリーランス作家としてキャリアを積んできました。トレンドに合った絵、多くの人に愛される絵を描くことが特に好きです。最近では音楽の雰囲気を最大限引き出せるミュージックビデオを作ることにとても興味があります。面白いご提案があればいつでもご連絡ください。

I like to recreate fascinating episodes from TV shows of my childhood, using the pinks that most girls love. I've built up a career as a freelance artist based on my illustrations. My specialty is bringing trends to life through illustrations that appeal to as many people as possible. These days, I am interested in creating music videos that really express the atmosphere of the music itself. Please let me know if you have any exciting proposals!

Special Works Created for *ASIAN ILLUSTRATION*

Cherry Popcorn by 인혜 VIVINOS / INH

Cherry Popcorn（ラフスケッチ）| (rough sketch)

Comment

こんにちは、VIVINOSです。韓国のK-Popアイドルスタイルと日本の原宿スタイルをミックスした、かわいい少女のイラストを描いてみました。今回の絵では、レトロ風特有の雰囲気と感性がピンク色にうまくマッチするように特に気を使って描きました。少女がはめている指輪は、実際に私が大事に持っているものばかりで、幼い頃を思い出して、見るたびに幸せな気分になります。

Greetings from VIVINOS! This cute young girl mixes the hip styles of Korea's K-Pop idols and Japan's Harajuku crowd. For this picture, I was extra careful to try to capture a retro mood and taste using pink hues. The rings on the girl's fingers are from my own collection. Each time I look at this drawing, it takes me back to my childhood days, bringing me joy.

RIRIFA

リリファ｜RIRIFA

Based in: 中国｜China
Language: 中国語 / 英語 / 日本語
Chinese / English / Japanese
E-mail: gorgeous-hua@qq.com
Web: http://ririfa.lofter.com/

Twitter: ririfaust
Instagram: ririfaust
Weibo: faustneo（@老浮 RIRIFA）
Pixiv: 81782
Tools: Photoshop / Procreate / SAI

Ririfa 2017

1. ミント猫｜Mint Cat

2. 教主｜Kingwoman

Profile: メインの仕事はゲーム会社の原画師です。仕事の絵はプライベートの作家活動の時の絵と作風が大きく違います。猫が大好きなので、いつか飼いたいですね! 猫を飼うことが最近の目標です。

I am the lead animator for a game company. My "corporate" and personal artistic styles are completely different. I love cats and would love to have one. In fact, that is my current goal.

Ririfa 2017

Ririfa 201704

4. 花のワッフル｜Flower Waffle

Comment: デジタル絵の世界で長く模索していた時期があり、色々な描き方を試してみて、やっと自分に合う方法を見つけました。今の鉛筆で描いたようなアナログ風の質感にとても満足していて、デジタルでもアナログのような風合いを可能にするソフトと機器にはとても感謝しています。今後も、自分と皆様が楽しめるような作品を作れるように頑張ります。

After a long period of struggling with digital art and trying out different drawing techniques, I finally found one that suits me well. I find the most satisfaction in the analog feel of pencils, and am grateful for software and hardware that allow me to recreate an analog feel digitally. I will continue to endeavor to make art that please both my fans and myself.

Sainker

サインカー｜Sainker

Based in: 中国｜China
Language: 中国語｜Chinese
E-mail: 1526425463@qq.com
Web: http://sainker.lofter.com/

Twitter: Sainker
Instagram: -
Weibo: sainker（@Sainker）
Pixiv: -
Tools: 透明水彩｜transparent water-colors / Photoshop CC

Profile: フリーランスのイラストレーターとして活動しています。時々、洋服と花のプリントのデザインもしています。最近は「花の擬人化」をテーマにしたイラストシリーズ「花の子ども」をメインに創作しています。

I am a freelance illustrator. I occasionally design clothing and floral textiles. Currently, my main project is a series called Flower Children, featuring personified flower blossoms.

1. 白の曼荼羅－光を育むゆりかご｜White Mandala – cradle that nurtures light　2. 黒の曼荼羅－闇を育むゆりかご｜Black Mandala – cradle that nurtures darkness　3. 水仙－月の落ちる夜｜Daffodils – night of waning moon　4. 鈴蘭－聖母の涙｜Lily of the Valley – Our Lady's Tears

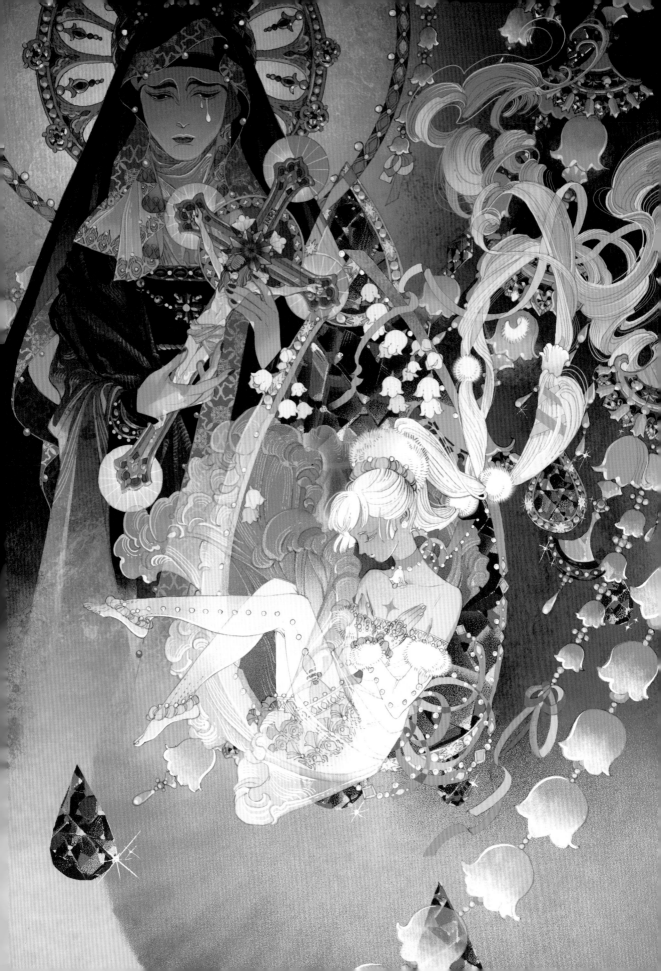

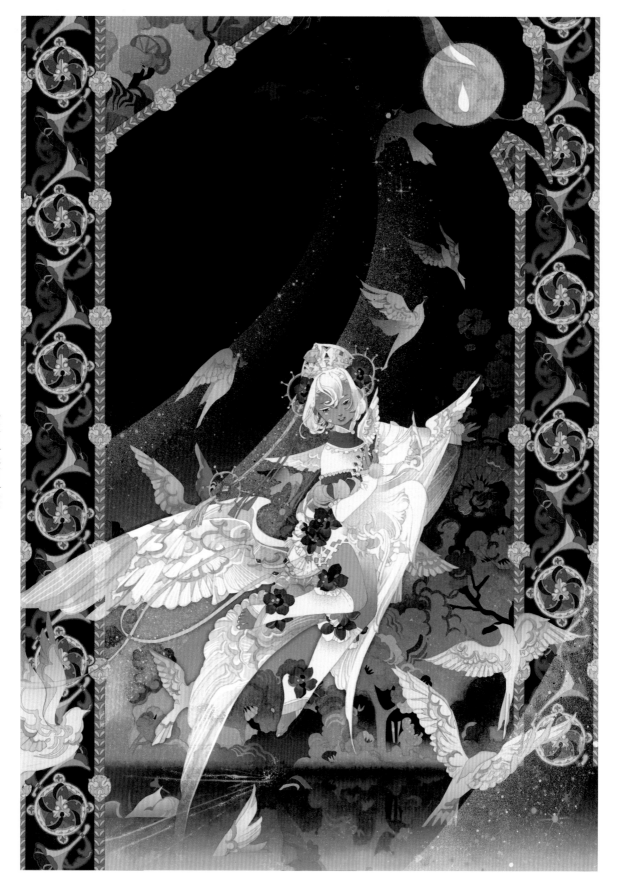

5. オオバナヒエンソウ−巣帰りの渡り鳥 | Delphinium Grandiflorum − the migration home

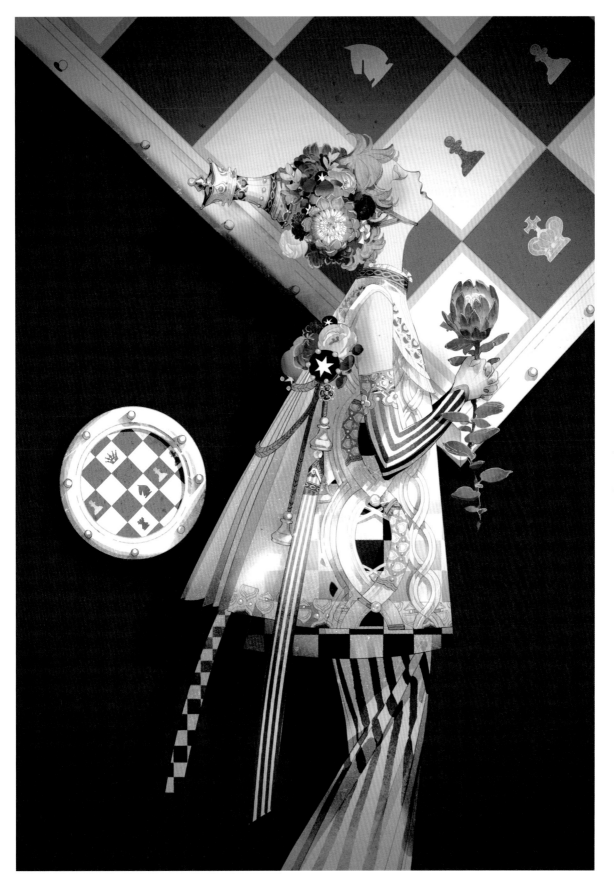

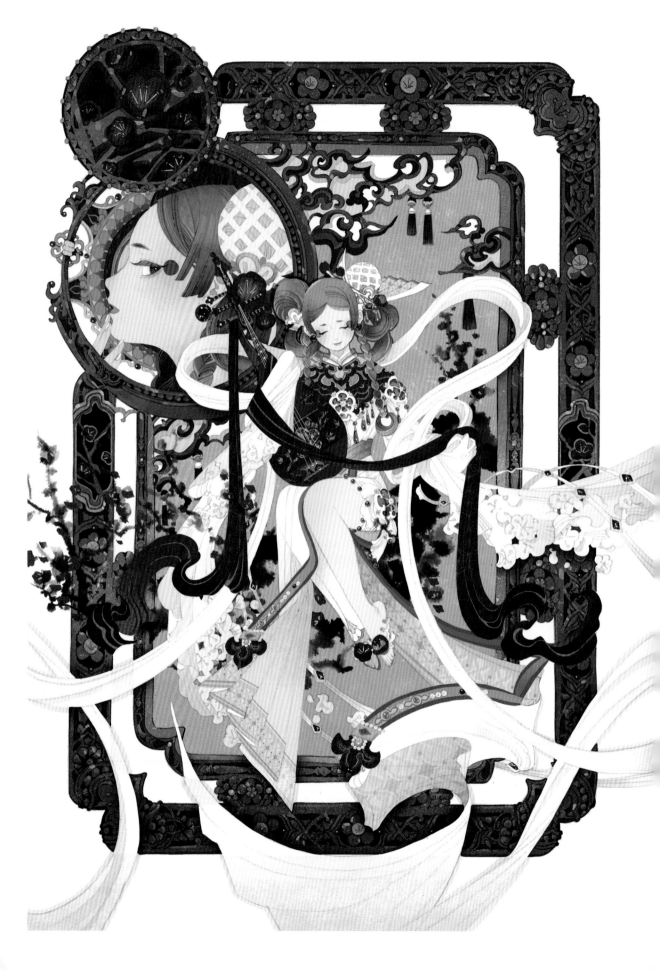

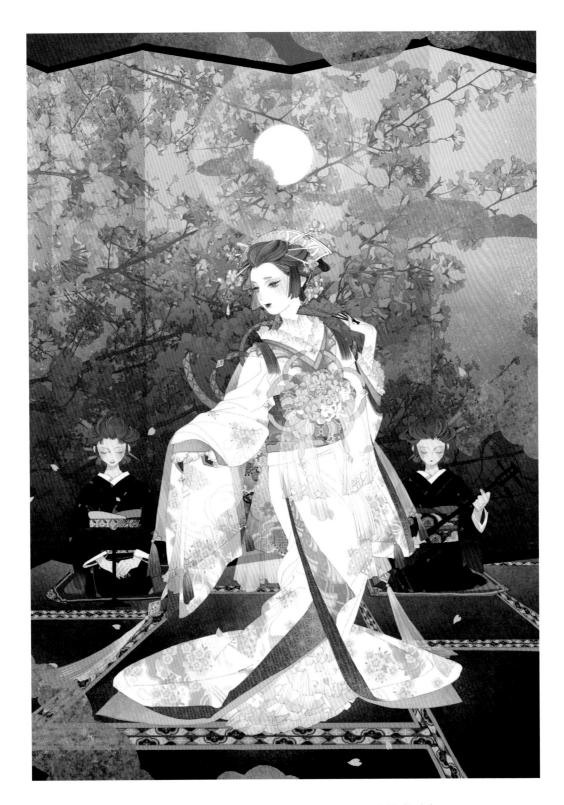

7. 紅梅－紅からの現れ｜Red Plum – a crimson vision

8. 桜－桜の舞｜Cherry Blossoms – sakura dance

Comment: 花・星・楽器などクラシックなモチーフが大好きです。自分のスタイルでその要素を再現するプロセスが楽しいです。昔の人々がそれらの要素に与えた物語や意味（および音楽作品）、自然が与えた様々な形、人工的な痕跡、それら全ては私に無限の想像力と興奮を与えてくれます。

I love classical motifs—flowers, stars, musical instruments, etc. Working with such motifs in my own style is a lot of fun. The stories and meanings that our ancestors infused into such motifs, or the musical compositions they wrote around them, the shapes of the natural world, the traces of human creation… all fill me with infinite imagination and a feeling of bliss.

幻電放映

ゲンデンホウエイ｜electroillusion

Based in: 中国｜China
Language: 中国語｜Chinese
E-mail: ttazn666@gmail.com
Web: https://electroillusionart.com/
https://sarnath.lofter.com/

Twitter: ttazn666
Instagram: electroillusion
Weibo: sarnath
（@幻電電電電電電電電）
Pixiv: 412469
Tools: Photoshop CC

1. 蜃気楼｜Mirage

2. 夢遊病｜Sleepwalking

Profile: クラゲ・宇宙・アフリカンのテーマが大好きです。イラストレーターとして劇場版アニメ『HELLO WORLD』のビジュアルデザイン、コスメのパッケージやゲーム『陰陽師』の宣伝イラスト等で幅広く活躍。自分のブランドを運営しつつ、製品の宣伝デザインも請け負い、様々な経験を積みました。

I love jellyfish, outer space, and African motifs. As an illustrator, I have worked on the visuals for the animated movie *Hello World*, cosmetics packaging, and promotional posters for the video game *Onmyoji*. As owner of my own brand, I have extensive experience in product advertising design and many other things.

5. エレベーターガーデン ｜ Elevator Garden

6. 水玉模様 ｜ Polka-dot Pattern

Comment: 儚さや幻想的で未来感のあるものが大好きで、暗い色と蛍光色で絵にコントラストをつけ、日常と離れた想像上の世界を創り出します。写真をよく見たり自分でも写真を撮ったり、いつも絵以外のアートから着想を得て、もっと面白いものを作りたいと思っています。絵の解釈は見る人で異なるので、絵が何を伝えているかより、自分が表現したいアイデアや感情を大事にしています。

I like the fragile, fantastical feel of futuristic things. I integrate dark and fluorescent colors for contrast, creating a world remote from daily life. Photography and other media bring me new perspectives and add an edge to my art. Since every viewer interprets art differently, I focus on what I want to express, rather than what my art communicates.

illumi

イルミ｜illumi

Based in: 中国｜China
Language: 中国語 / 英語
Chinese / English
E-mail: sliu13@sva.edu
Web: -

Twitter: illumi99999
Instagram: illumi999
Weibo: 5329902398（@螺丝辣翅面）
Pixiv: -
Tools: Photoshop CC 2020 /
Procreate / Intuos CTL 6100

illumi｜China｜078

1. Dawn Blue

Profile: 中国蘇州生まれ。旅行、音楽、デザインが好きです。スクール・オブ・ビジュアル・アーツ (School of Visual Arts) のイラスト専攻4年生です。

I was born in Suzhou, China. I like travel, music, and design. I am currently a 4th year student majoring in illustration at the School of Visual Arts.

Comment: ゆったりとした、曖昧でヴィンテージな雰囲気を表現したいです。陽が昇る時や沈む時、その太陽の光でキラキラ空気中で輝くチリを描くのが大好きです。物事の一瞬の美しさを絵で描けるようになりたいです。

I strive to express a relaxed, vague yet vintage atmosphere in my art. My favorite thing to draw is the floating dust that sparkles in the sunlight at dawn or at dusk. My goal is to be able to draw the beauty of each moment no matter what the event or subject.

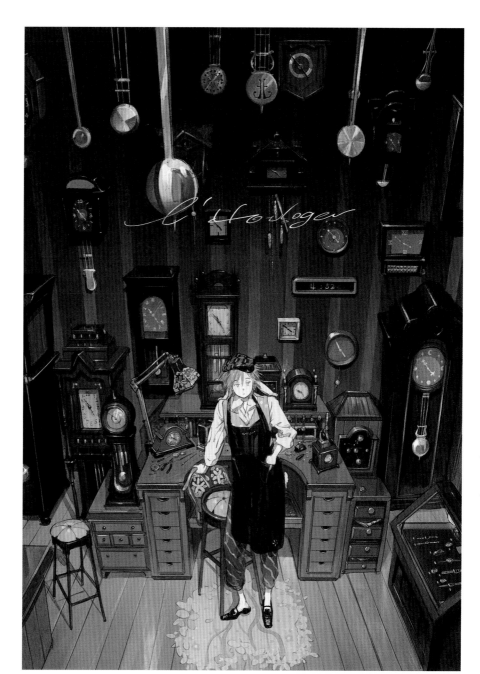

4. l'Horloger

孙无力

ソン・ムリョク｜sunwuli

Based in: 中国｜China
Language: 中国語｜Chinese
E-mail: 1593605075@qq.com
Web: -

Twitter: -
Instagram: sunwuli_fiveli
Weibo: 2238601175（@孙无力）
Pixiv: -
Tools: SAI / Photoshop CC

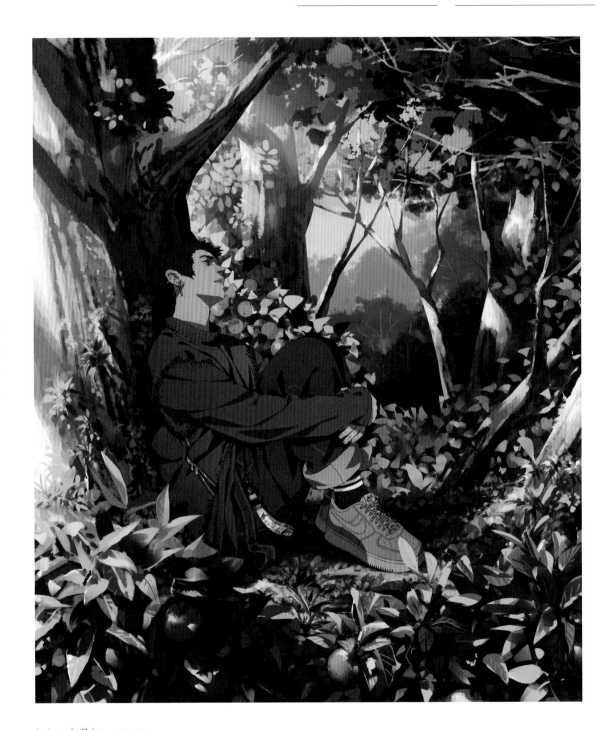

1. オレンジの陰｜Orange Shadow

Profile: 自分を主人公に、自分の生活を背景に、自分の感情を脚本にして、自分だけの「日記」を絵に描き続けて、たくさんの方から注目してもらえるようになりました。

My works feature myself as the main character, my life as the background, and my feelings as the script. As I have continued drawing a "picture diary" of my life, I have gained evermore fans and recognition.

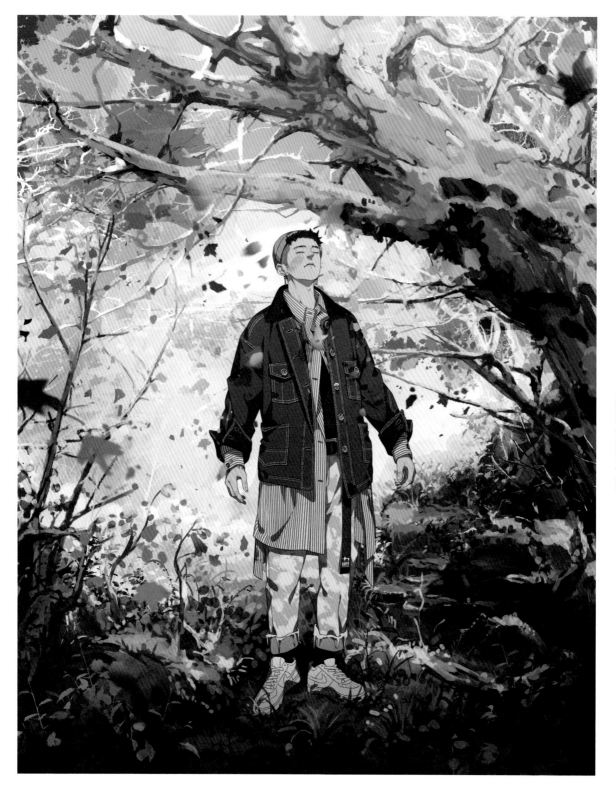

2. 秋の葉 | Autumn Leaves

Comment: 子供の頃から日本のアニメの影響を受けてきました。日本のセル塗りが大好きです。田舎育ちなので、自然の風景に惹かれます。光の表現がまだ弱いので、今後はそこをもっと研究したいと思っています。

I was influenced by Japanese anime as a child. I really like Japanese cel (celluloid) painting. My rural upbringing seems to draw me to natural scenery. Yet I lack skill when it comes to depicting light, and would like to study that going forward.

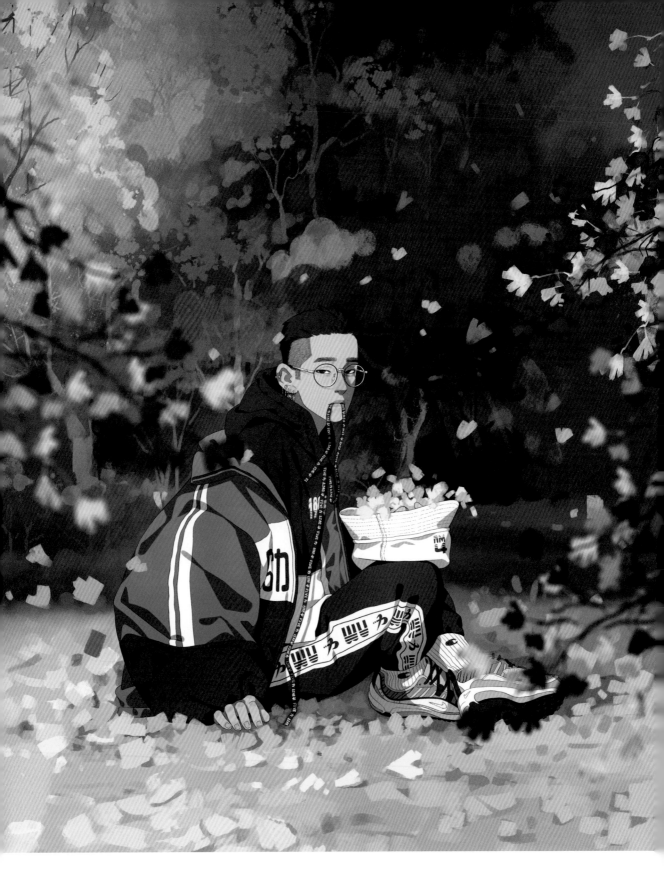

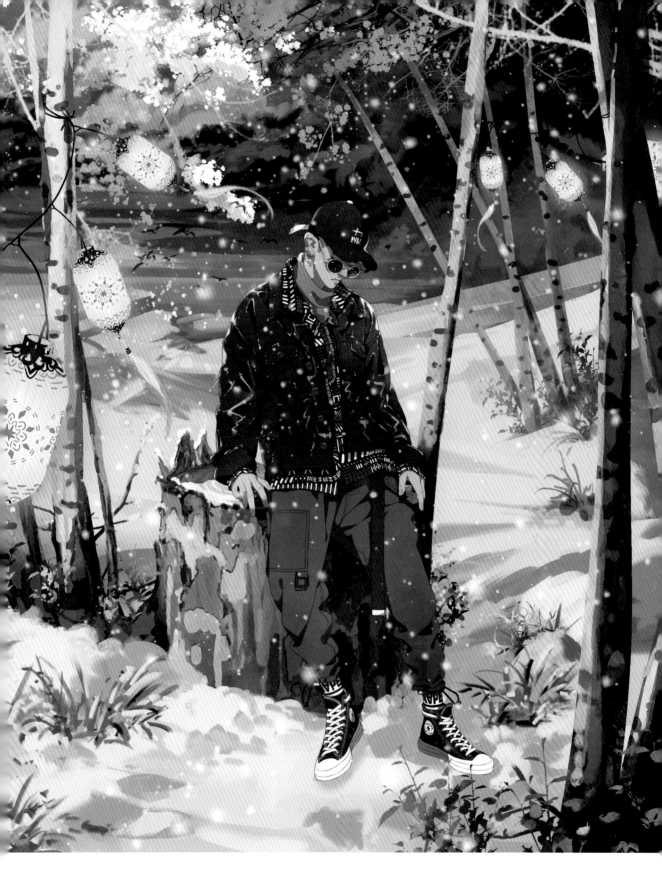

4. 灯り雪 | Light Snow

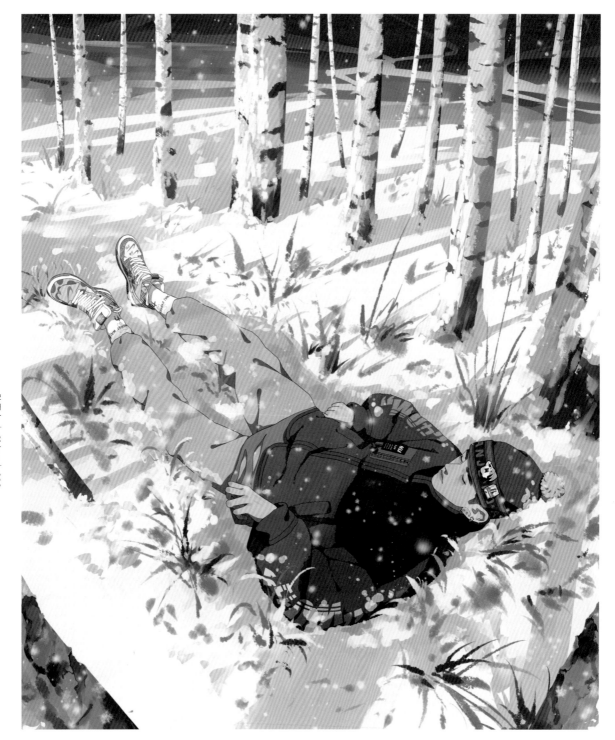

5. 雪蔵｜Snow Sleep

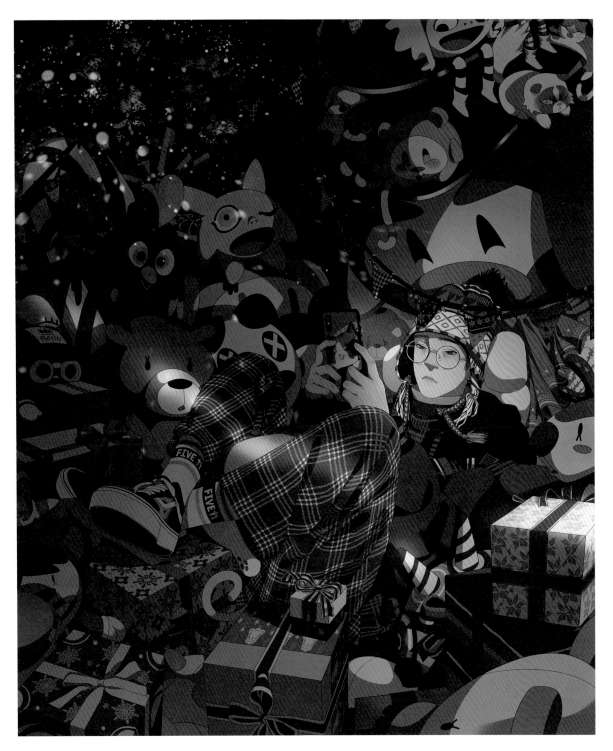

6. ギフト | Gifts

grandia 元

グランディアユァン｜grandia

Based in: 中国｜China
Language: 中国語 / 英語 Chinese / English
E-mail: 520zmj@163.com
Web: -

Twitter: grandia42783429
Instagram: -
Weibo: grandialee（@grandia 元）
Pixiv: 16916292
Tools: Photoshop CC / SAI2

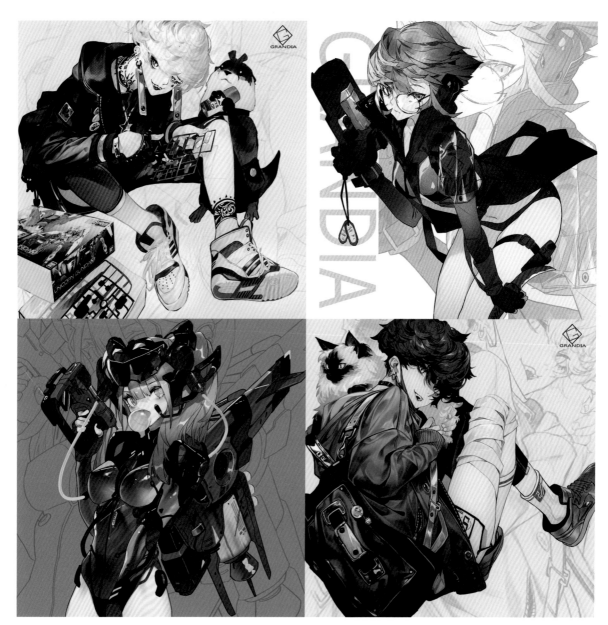

grandia 元｜China｜088

Profile: 中学から絵の勉強を始め、最初は好きなゲームキャラクターを落書きしていました。自分が創ったキャラクターがゲームに登場できるといいなと思い、美大を出て今はゲーム会社で働いています。モットーにしている言葉は love and share。

I began studying art in junior high school, initially sketching my favorite game characters. As I started creating my own characters, I hoped to see them appear in games someday. I graduated from an art university and now work for a video game company. "Love and share" is my motto.

1	2	
3	4	5

1. 2. 3. 4. 5. 無題｜Untitled

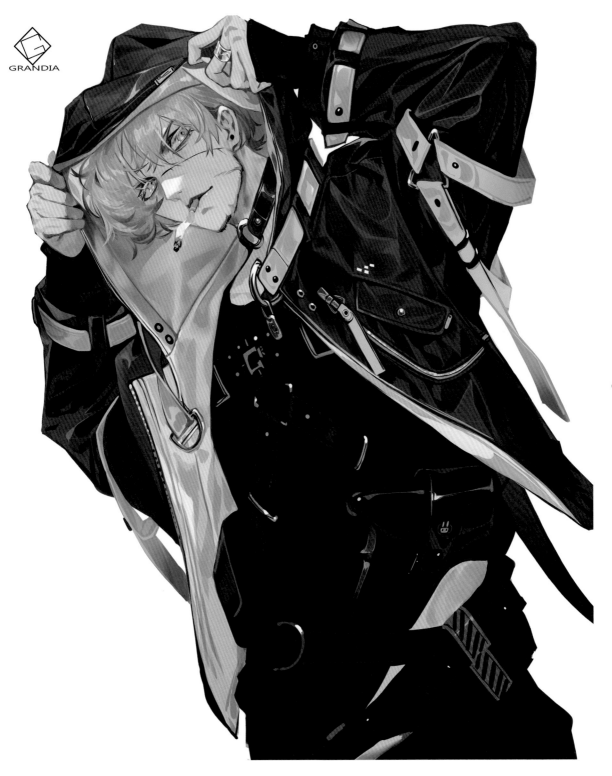

Comment: キャラクターを描いたりデザインしたりするのが好きです。お洒落でファッショナブルなものに惹かれます。また、メカの創作にも興味があります。

I love drawing and designing characters. I am intrigued by stylish and fashionable things, but also enjoy creating robots and other mecha-related subjects.

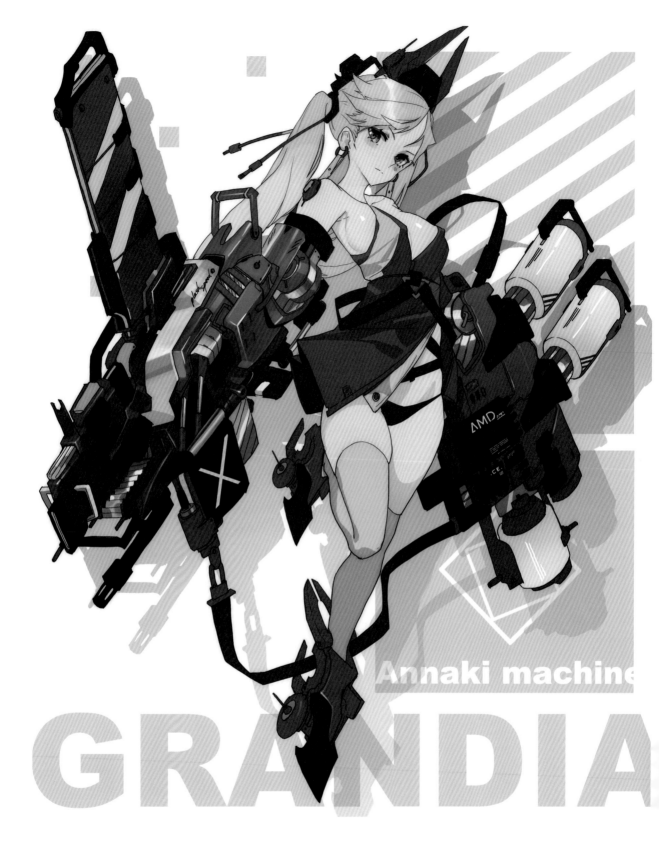

Annaki machine

GRANDIA

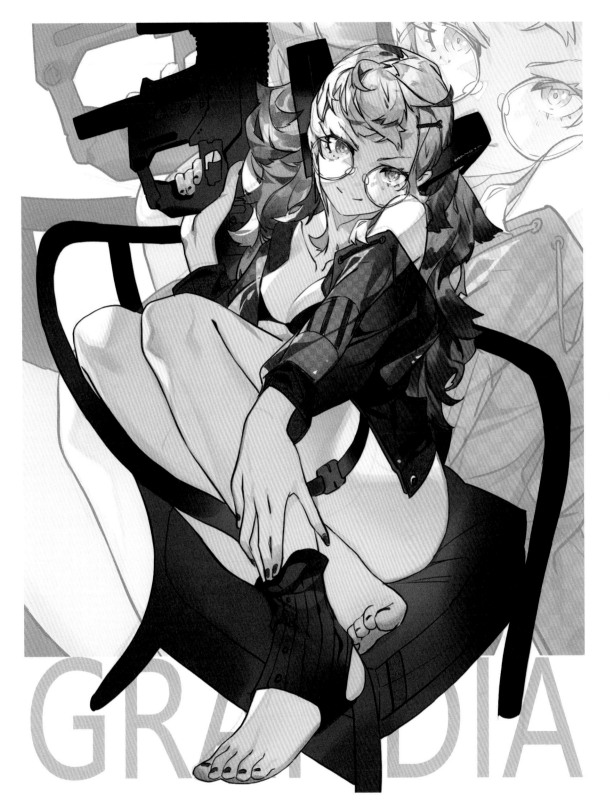

grandia 元 | China | 091

7. 無題 | Untitled

GHARLIERA

ガリエラ｜GHARLIERA

Based in: 韓国｜Korea
Language: 韓国語 / 英語 / 日本語
Korean / English / Japanese
E-mail: gharly@naver.com
Web: https://gharliera.com/

Twitter: −
Instagram: gharliera
Weibo: −
Pixiv: −
Tools: Photoshop / Intuos Pro

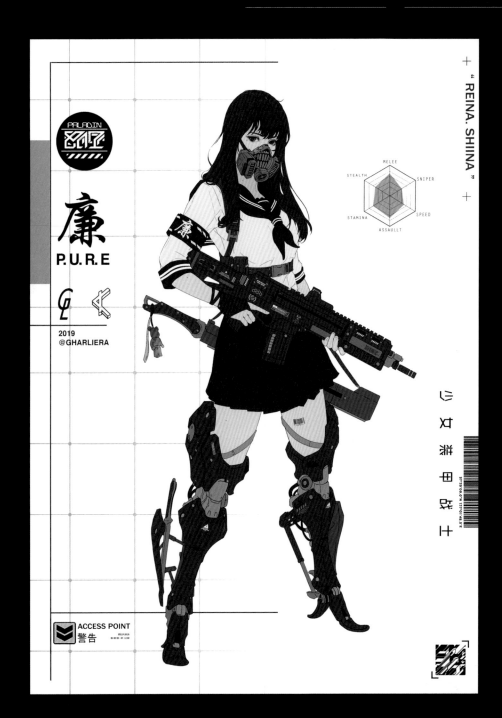

Profile: コンセプトアーティストを経て、現在はイラストレーターとして活動しています。少女と機械が融合したサイバーパンク少女シリーズで、大きな注目を浴びました。ファッション、音楽、イラスト、ゲーム等いろいろな分野で様々なことに挑戦しています。

I began as a concept artist and now work as an illustrator. My Cyberpunk Girl series fusing the women with machinery put me in the spotlight. I take on projects in various fields, including fashion, music, illustration, and video games.

1. 2. 5. Cyberpunk Schoolgirl **3.** SERPENT **4.** HALLUCINATION

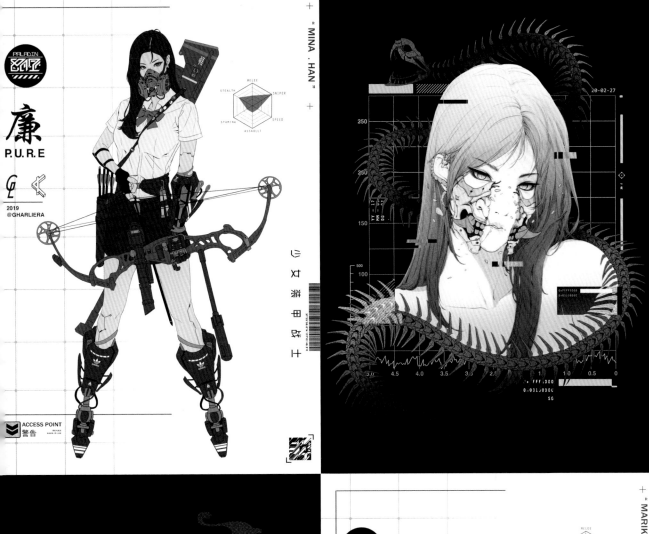
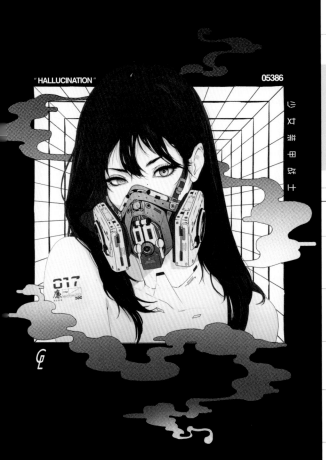
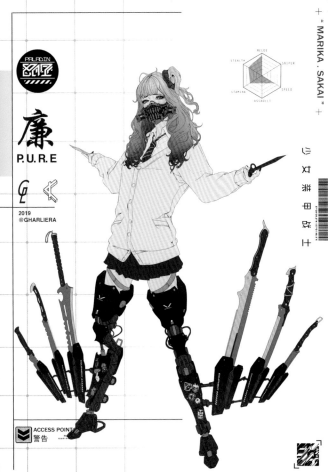

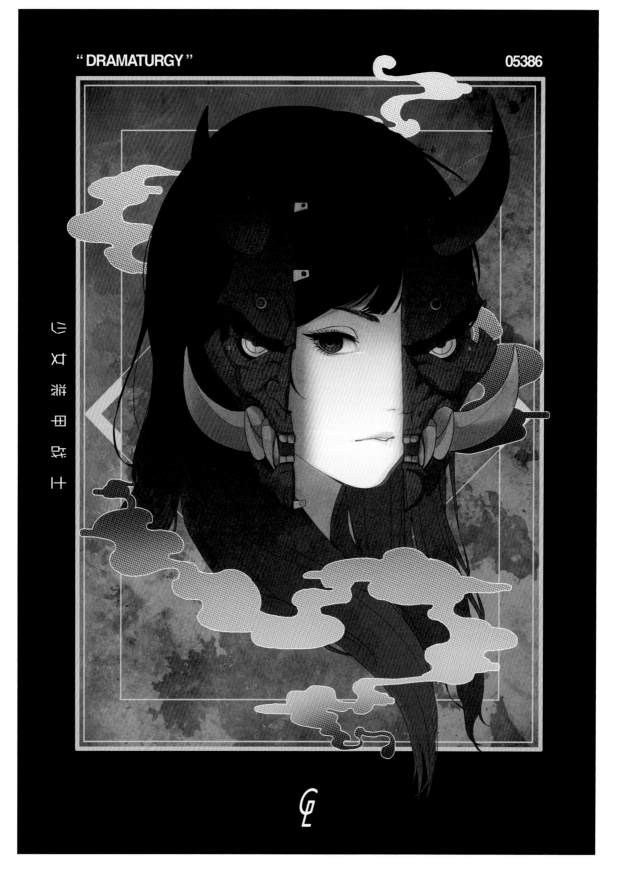

少女兵甲战士

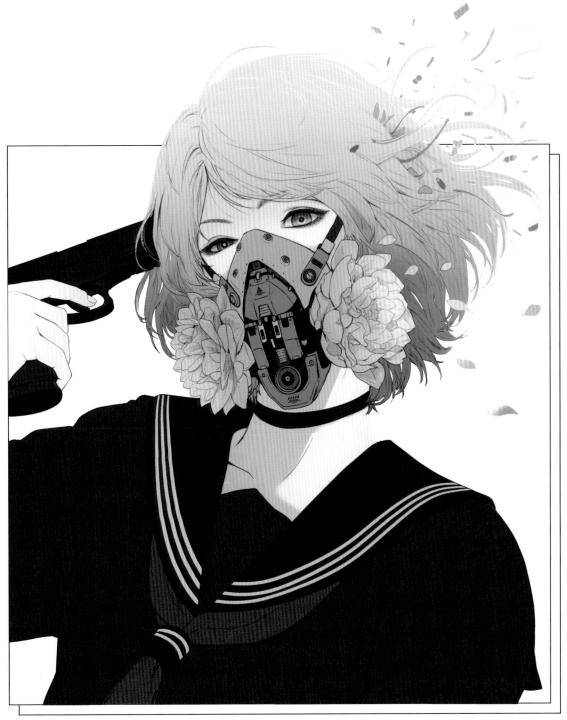

" D E L E T E "

GHARLIERA Collection
Spring - Summer 2020

7. DELETE

Comment: 少女と機械、純粋さと人為的なもの、自然と工学、これらのように正反
対の性質を持つものを融合し、その中から異質な美しさを表現したいと
思っています。

I strive to express otherworldly beauty by fusing young girls and
machinery, purity and artificiality, the natural and the engineered,
and other diametric opposites.

Novelance

ノヴェランス｜Novelance

Based in: 中国｜China
Language: 中国語 / 英語
Chinese / English
E-mail: novelance@foxmail.com
Web: https://www.artstation.
com/novelance

Twitter: novelance
Instagram: -
Weibo: 2008309891 (@_Novelance)
Pixiv: 10710834
Tools: Photoshop CC / 3ds Max

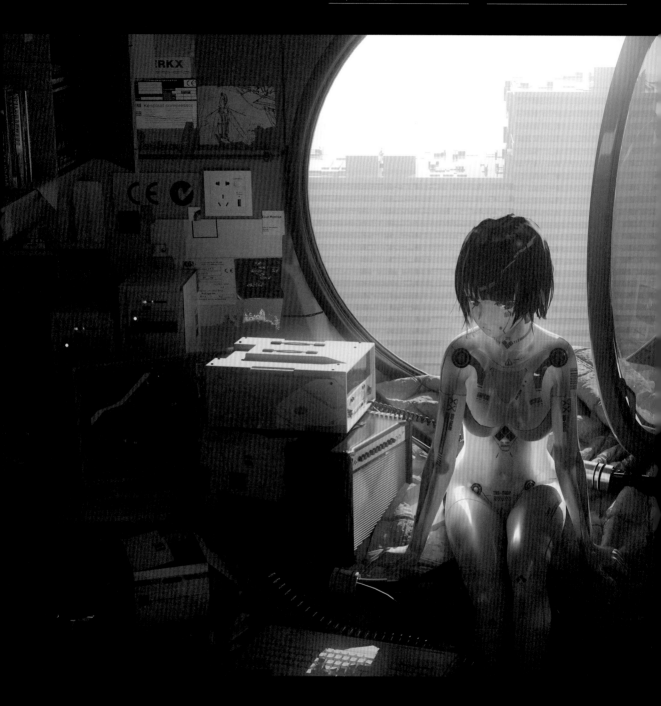

Profile: もともと情報工学専攻で、卒業してから趣味で絵の勉強を始めました。2年ほどでゲーム会社の原画デザイナーに転職し、そこから絵が主な仕事になりました。3Dスキルも学び、イラストに応用して注目を集めるようになり、コンセプトデザイナーとして今に至ります。

I studied art as a hobby after graduating with a major in information engineering. I started my art career working as an animation designer for a video game company for about 2 years. My illustrations began to garner attention after I gained 3D skills, and I eventually became a concept designer.

1. Cyborg **2.** 侍 | Warrior

5. Garage 8 6. WINd

3. 午後 | Afternoon 4. AERONAUTICLOG

Comment: 他のイラストレーターと比べて、美術教育を受けておらず、絵の基礎が弱いほうだと思います。ただ創作する上では、創りたい心のほうがもっと大事で、絵でも造形でも、自分が正しいと思うことをやり遂げなければいけないと思ってきました。一枚の絵の背後には一つの完全な世界があると思います。絵はその世界を覗くための窓。自分の役割はその世界をできる限り見せることだと思います。

Due to my lack of formal art education, I fear that my basic drafting skills are on the weak side. However, when it comes to making art. whether it be 2D or 3D media, the raw desire to create is the most important, I decided simply that I must do whatever it is that I think is right. I believe an entire world lies behind each work — the picture serves as a window through which we peek. My role is to offer the best possible view of that world.

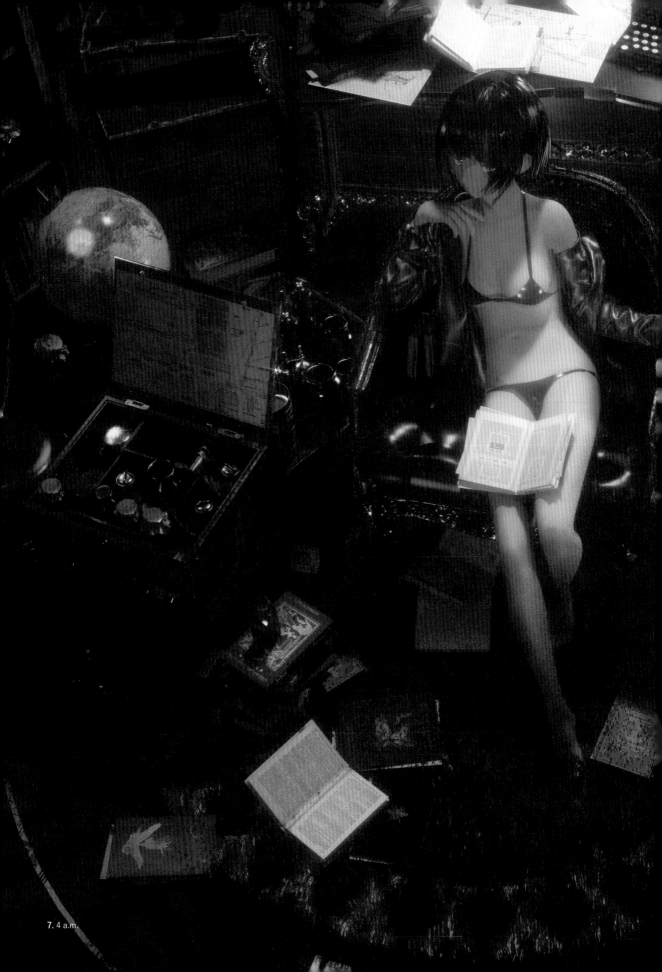

纹银

ミン | Ming

Based in: 中国 | China
Language: 中国語 / 英語
Chinese / English
E-mail: mingatelier@vip.qq.com
Web: http://mingatelier.lofter.com

Twitter: -
Instagram: -
Weibo: akira1208 (@纹银-MING)
Pixiv: -
Tools: Photoshop

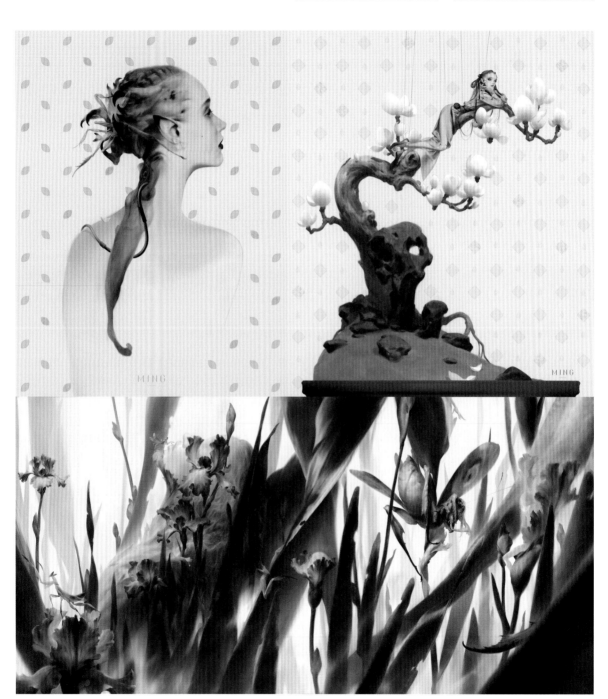

Profile: 2007年に新卒でゲーム会社テンセントに入社。3年半で独立し、フリーランスに。一度東京のゲーム会社アプリボットで働き、『Legend of the Cryptids』に関わった絵は代表作となりました。最近はイラストレーターとして独立し、ゲームの作風とは離れています。

After graduating in 2007, I joined Tencent, a video game company. I went freelance after 3 and a half years. I created my best work for *Legend of the Cryptids* while working in Tokyo at Applibot. Recently, I have become an independent illustrator, moving away from game-style artwork.

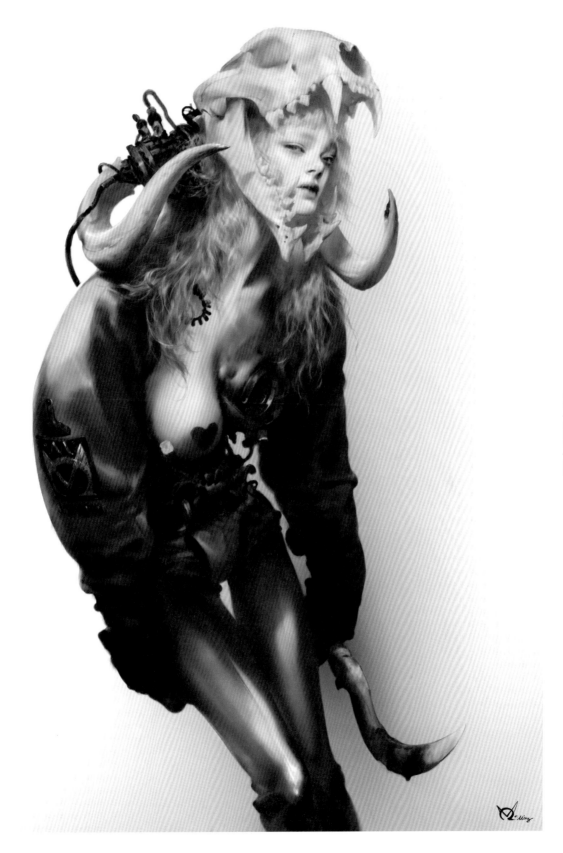

5. 蟲 | Worm

Comment: 子供の頃は水彩とアクリルで描いていました。中国画も勉強したことが
あって、デジタル絵を描いてもやはり水彩の質感を再現したくなります。
好きなアーティストは天野喜孝さん、寺田克也さん、空山基さんです。
最近は人間の多面性や人と人の関係性を表現したいと思っています。
人を異化したり、もしくは他の生物を擬人化し、人間の本質を見つめる
ことがこれからのテーマです。

As a kid, I used watercolors and acrylics. I even studied Chinese
painting. Even with digital drawing, I try to reproduce the watercolor
feel. My favorite artists are Amano Yoshitaka, Terada Katsuya, and
Sorayama Hajime. Recently, I have been trying to capture the rich
complexity of human beings and their relationships with one another,
as well as their metamorphosis into other creatures.

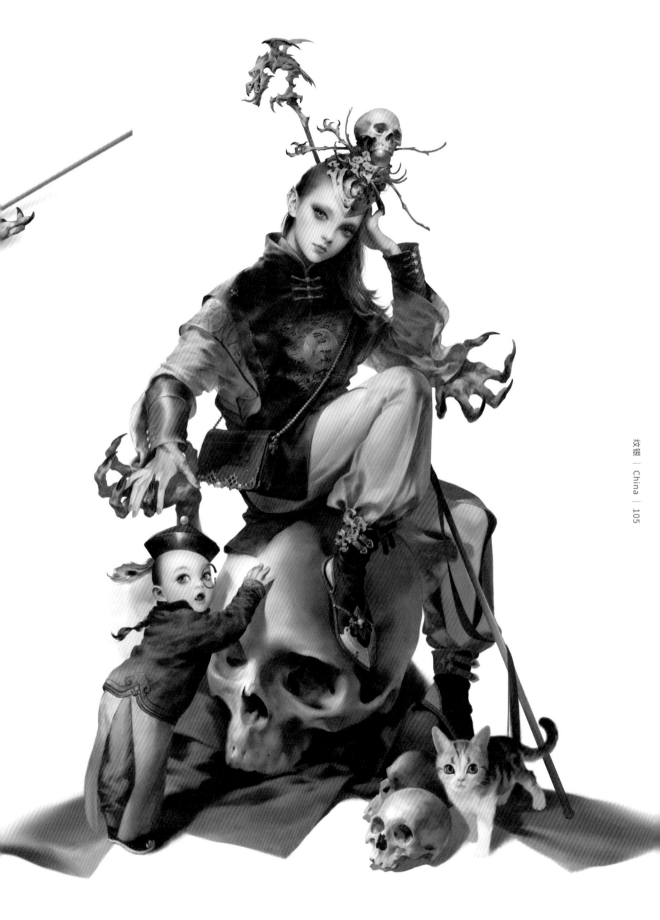

6. 母子図 | Mother and Son

FKEY
フェキー｜FKEY

Based in: 中国｜China
Language: 中国語｜Chinese
E-mail: 540631683@qq.com
Web: -

Twitter: fkey123
Instagram: -
Weibo: fkey (@FKEY-)
Pixiv: 1197484
Tools: CLIP STUDIO PAINT

FKEY｜China｜106

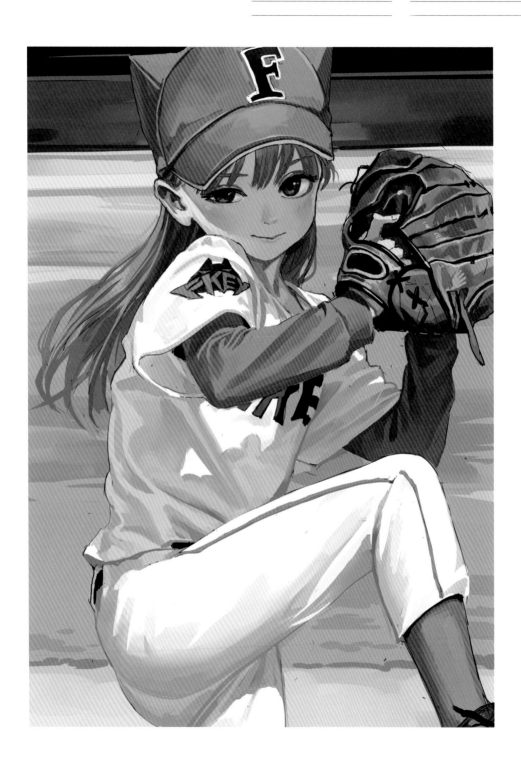

Profile: フリーランスのイラストレーター。キャラクターを描くのが得意です。　　As a freelance illustrator, depicting human characters is my forte.

1	2	3
	4	5

1. 野球少女 - ピッチャー｜Baseball Girl - Pitcher　2. 野球少女 - 帽子のつば｜Baseball Girl - Cap Rim　3. 野球少女 - スイング｜Baseball Girl - Swing
4. 野球少女 - インタビュー｜Baseball Girl - Interview　5. 野球少女 - 野球帽｜Baseball Girl - Baseball Cap

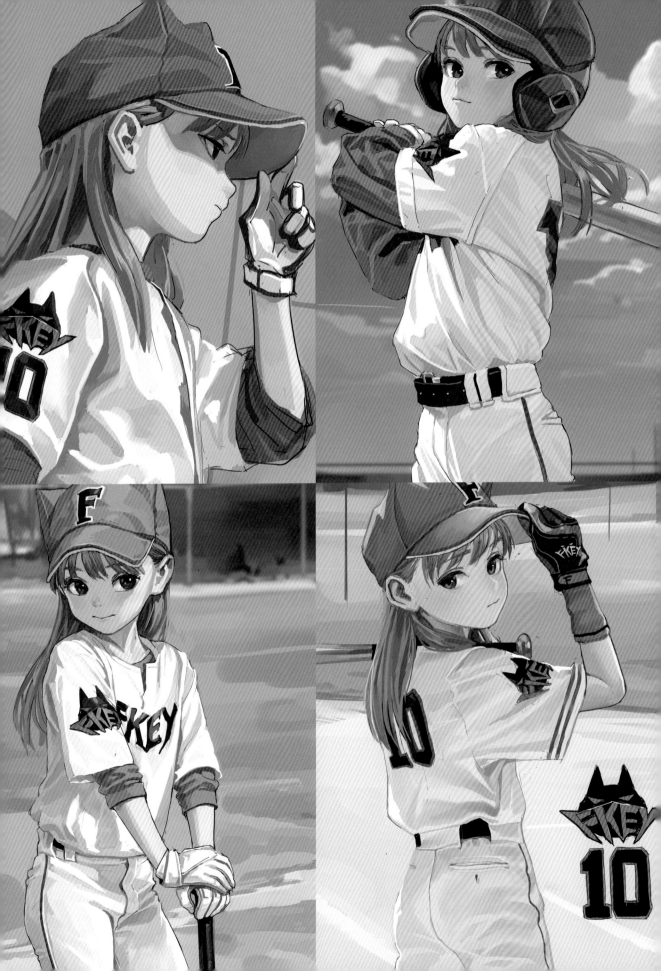

7. メイド - 軌跡 │ Maid - Tracks

6. メイド - 雪のハンター │ Maid - Snow Hunter

Comment: 人物の表情や動きから繊細な感情を表現するのが好きです。あまり細部まで描くことにはこだわっていません。服のシワの表情を描くのが楽しいです。

I love articulating nuanced emotion through characters' expressions and movements. I don't like to fuss with minute details, but I do enjoy capturing expressions in the wrinkles of clothing.

NoriZC

ノリ | NoriZC

Based in: 中国 | China
Language: 中国語 | Chinese
E-mail: 772340586@qq.com
Web: https://www.behance.net/norizc

Twitter: NoriZCl
Instagram: norizci
Weibo: 1893202410 (@NoriZC)
Pixiv: 4592232
Tools: Photoshop / SAI

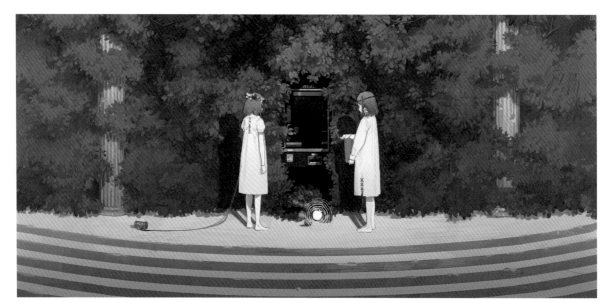

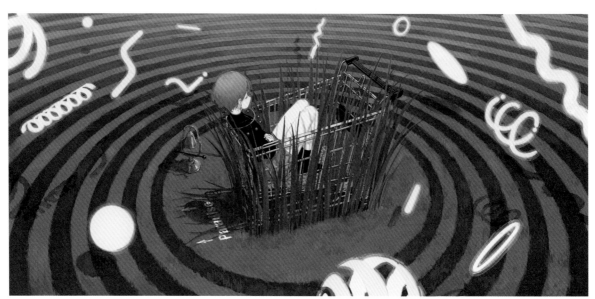

1. ゴールデンアップルの楽園 | Golden Apple Paradise　　**2.** 楽園 | Paradise

3. 楽園 | Paradise

Profile: 2017年、中国美術学院総合デザイン学科卒。2年間フリーのイラストレーターを経験し、HyperGryphに就職。ゲーム『Arknights』の美術開発を担当。今でも仕事と創作の両立で悩んでいます。

I graduated from the China Academy of Art in 2017 with a degree in integrated design. After 2 years of experience as a freelance illustrator, I joined HyperGryph and oversaw art development for the game *Arknights*. I always worry about the balance of work/creativity in my life.

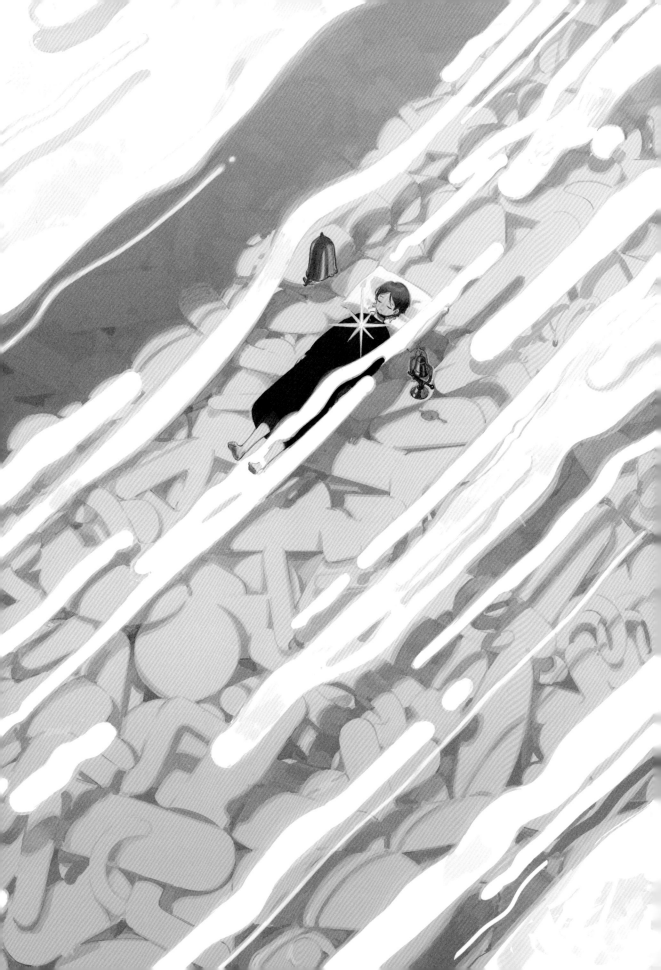

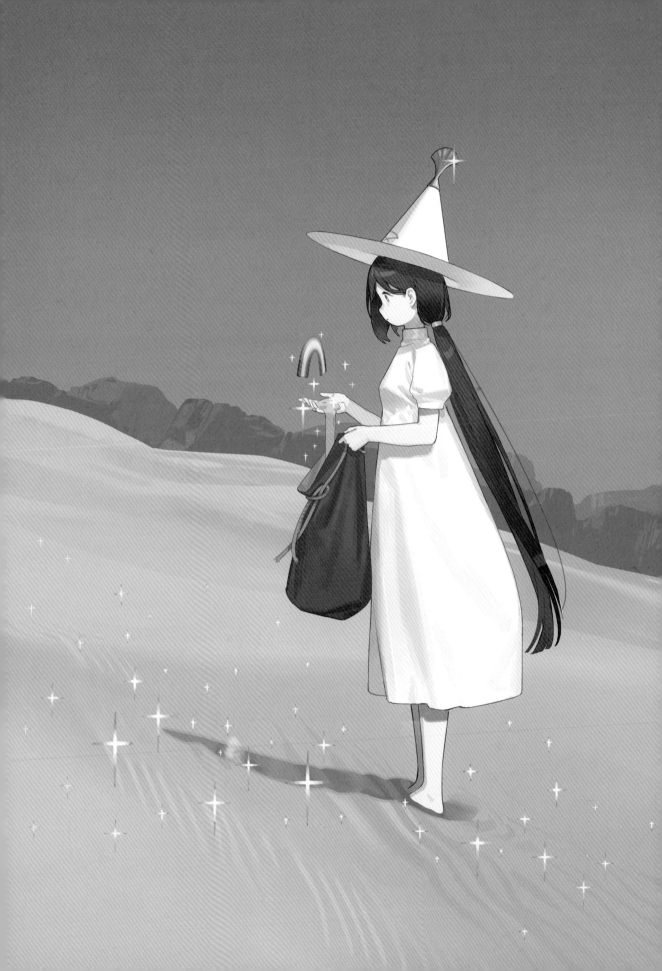

4. 5. 虹を創った人 | Rainbow Maker

6. 兵士、修道女、詩人 | Soldier, Nun, Poet

Comment: 心の中にある、希薄な感情やいっぱいに広がる空白、瞑想をしているようなぼんやりと霞む景色を再現したいです。「怪談」とも「童話」とも異なる、恐怖でも幸福でもない中間の状態です。「強烈な感情」も悪くはないですが、私は純粋な「空白」に包まれて羊水の中にいるような安心感が好きです。

I strive to recreate scenes imbued with dreamy ambiguity, as if one is meditating, with the faint emotions and spreading emptiness found inside the human heart. Unlike ghost stories or fairy tales, these are neither scary nor happy—just neutral. Intense emotions are fine, but I prefer the secure feeling of being surrounded by pure emptiness, as if suspended in amniotic fluid.

俊西 JUNC

ジュンシー｜WENJUN LIN

Based in: 中国｜China
Language: 中国語／韓国語／英語
Chinese / Korean / English
E-mail: 21178233@qq.com
Web: http://junc.artstation.com/

Twitter: -
Instagram: wenjun.lin
Weibo: juncart（＠俊西 JUNC）
Pixiv: 23791720
Tools: Photoshop CC / Cintiq 16

Profile: 大学の油絵専攻を卒業後、漫画の仕事を3年、ゲーム美術デザイナーを8年経験しました。退職後は独立し、BLIZZARD、テンセント、ネットイースに契約イラストレーターとして参加。『千里幽歌（GHOST）』を独立出版して、最近は自分のブランドでこの漫画から派生した玩具を製造、GHOST 2部も継続中です。

After graduating with a major in oil painting, I worked as a manga artist for 3 years and a game art designer for 8 years. As an independent contractor, I illustrate for BLIZZARD, Tencent, and NetEase. After self-publishing the manga GHOST, I initiated my own brand for manufacturing toys based on the manga. I am currently working on GHOST 2.

1	2	4
3	5	

1. 幽霊少女｜Ghost Girl　**2.** 秋物語｜Autumn Story　**3.** 赤い乙女｜Red Girl　**4.** 幽霊の子｜Ghost Boy　**5.** 夏夢｜Summer Dream

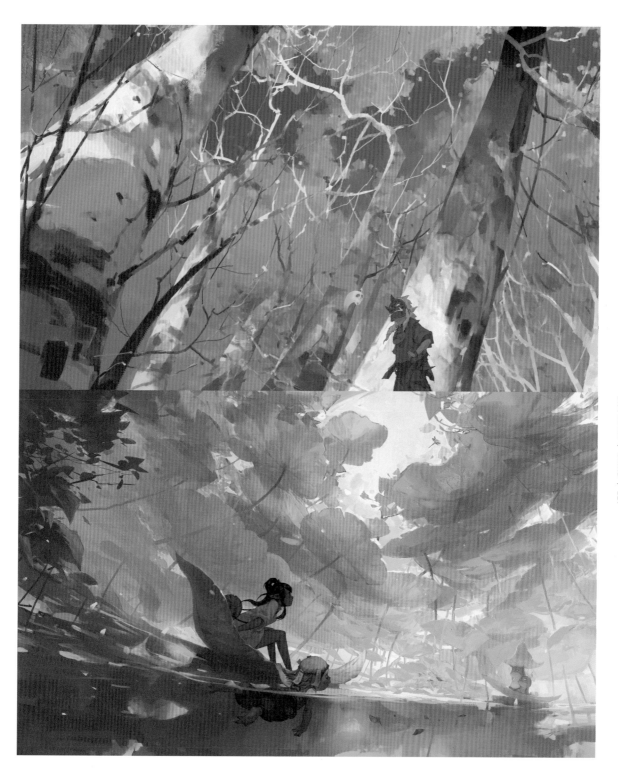

Comment: 息をするように自然に、感情をそのまま作品に表現できている時が楽しいです。人それぞれ個性は違いますが、物への感知力は共通だと信じています。もっと注意深くそれを観察しなければならないと思っています。絵を描くことは自分にとってもう一つの不思議な世界に入るための儀式です。悩んだ時にいつも思い出す言葉は、「人生は戻ることのないブーメラン、トキメキの方向に進むべき」。

I am happy when I am able to express my feelings through art as naturally as I breathe. Though each of us has a unique personality, we share a common sensitivity toward things in the world, a faculty that we all need to explore more deeply. Drawing is a ritual that transports to me to another, more mysterious world. Whenever stuck, I tell myself, "Life is a boomerang that never comes back — let it move you in thrilling directions."

咸鱼中下游

シェンユジョンシャヨ | Blaine Zhou

Based in: 中国 | China
Language: 中国語 / 英語
Chinese / English
E-mail: 377858279@qq.com
Web: -

Twitter: -
Instagram: -
Weibo: zhongxiayou (@咸鱼中下游)
Pixiv: -
Tools: Photoshop CS6

Profile: 現在、上海に在住。独学で絵を学び、今は上海音楽学院で音楽を勉強しています。絵での成功は考えてなくて、精神の自由を大事にしています。絵や音楽や詩は、自分の精神を表現するための媒体に過ぎません。自分の力で人を助けることを望んでいます。

I currently live in Shanghai. Although a self-taught illustrator, I am now studying music at the Shanghai Conservatory. I value spiritual freedom in drawing, not success or failure. Art, music, and poetry are simply tools for expressing one's spirit. I hope to help others via my efforts.

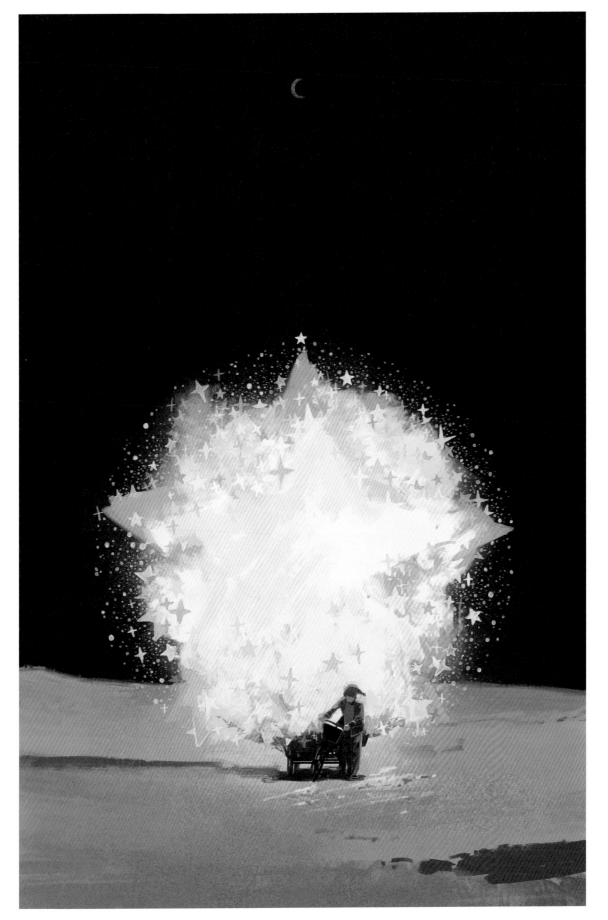

5. 星の群れのウィンドチャイム｜Windchime of Stars **6.** 終焉｜The End **7.** 君のためなら宇宙を摘む｜I'd Grasp the Universe for You

Comment: 自分の絵の理論では、技法は着想のためにあり、色彩はその着想を伝える一つの重要な媒体と考えています。なので、色使いから自分の心理的変化を覗くことができます。ここ数年、双極性障害に苦しんでいて、いつも極端な興奮と落ち込みを繰り返しています。闇と光が同時に流れているため、絵に黒と鮮やかな色を同時に使うことで、その心境を表現しています。

My personal theory of art is that technique is for the development of ideas while color is a vehicle for communicating them. I can see my own psychological changes reflected in my use of colors. For the past few years, I have suffered from bipolar disorder, living a cycle of extreme excitement and depression. The darkness and light flow simultaneously, which I express using black and bright colors together.

REDUM

レッドム｜REDUM

Based in: 中国｜China
Language: 中国語｜Chinese
E-mail: 1037510741@qq.com
Web: -

Twitter: REDUM4
Instagram: -
Weibo: 2004707471（@-REDUM-）
Pixiv: 15825259
Tools: Photoshop CC／透明水彩
Transparent watercolors

1. ライチ｜Lycees

Profile: 中国のイラストレーター。グラフィックデザイナー。ゲームのお仕事をしています。

I am a Chinese illustrator and graphic designer working in the game industry.

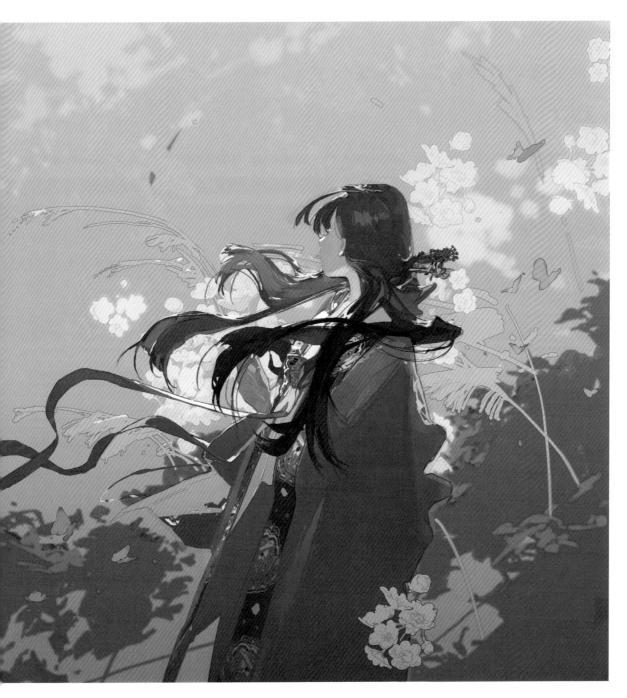

2. 春風 │ Spring Breeze

Comment: 優しくて美しいものが好きです。人を感動させるような綺麗なシーンを創りたいです。

I like things that are gentle and beautiful, and I strive to create pretty scenes that stir emotions in the beholder.

5. フローラル │ Floral

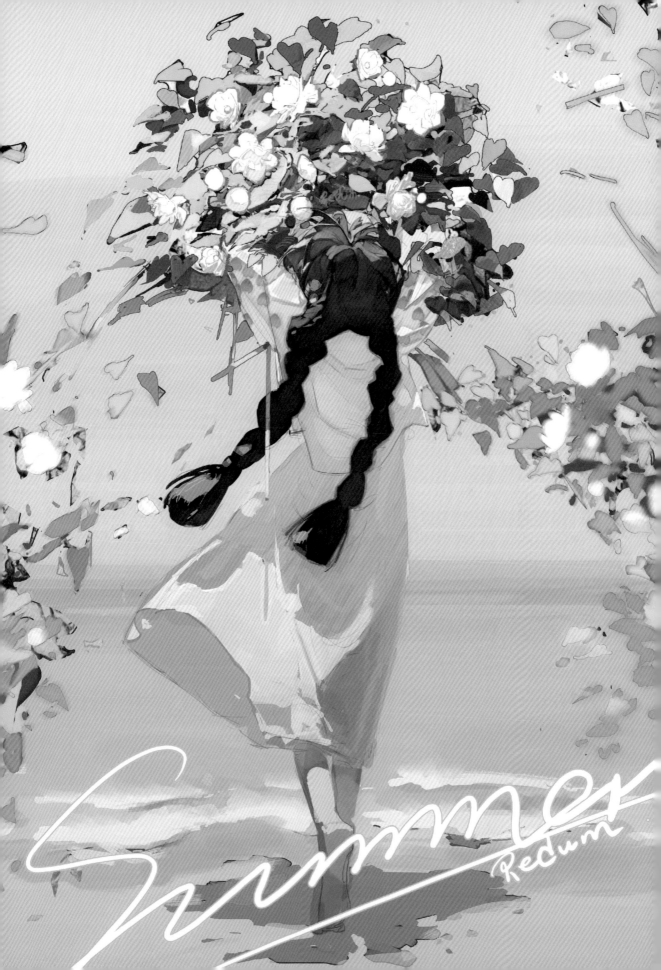

sheya

シヤ | sheya

Based: 中国 | China
Language: 中国語 / 英語
Chinese / English
E-mail: sheyatin141@gmail.com
Web: https://dingdingkuang.lofter.com/

Twitter: dingkuang1
Instagram: sheya_tin
Weibo: sheyatin（@丁丁框）
Pixiv: 4022652
Tools: Procreate / Photoshop CC

1. 違う季節 | Different Seasons

Profile: 清華大学美術学院視覚伝達専攻の学部生です。学校以外の時間に、iPad で絵を描いてインターネットに投稿しています。また、ゲームや映画の宣伝イラスト、本やCDのジャケットイラスト、オンライン授業の講師など商業の仕事もしています。

I am majoring in visual communications at the Academy of Arts and Design at Tsinghua University. When not in school, I draw on my iPad and post the results online. I earn a living by illustrating ads for games, movies, and jacket covers for books and CDs, and also teaching online.

Comment: ファインアートを勉強し、デジタルメディアにも触れたことで、印象派など
の伝統的な絵画をどうやってデジタルアートに応用するかを考えること
が趣味になっています。物語性や雰囲気のあるイラストが大好きなので、
雰囲気を伝えるために色使いに気を配り、それが徐々に自分の特徴に
なっていきました。今後はもっと絵のテーマを広げたいです。皆様に新
しさを感じてもらえたら幸いです！

I study the fine arts and explore digital media. I like to think about
how I can apply traditional styles (such as Impressionism) in digital
art. I love atmospheric, story-based illustrations, and strive to em-
ploy unique coloring methods to convey moods in my own work. I'd
like to broaden my themes, bringing a fresh spark to all who view my
work.

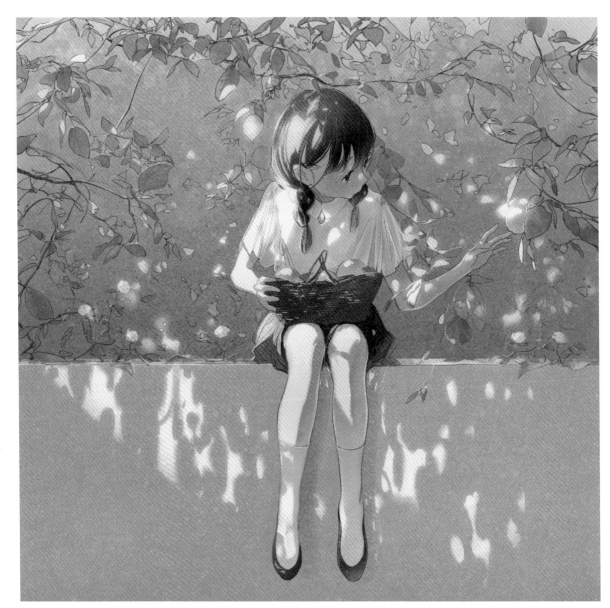

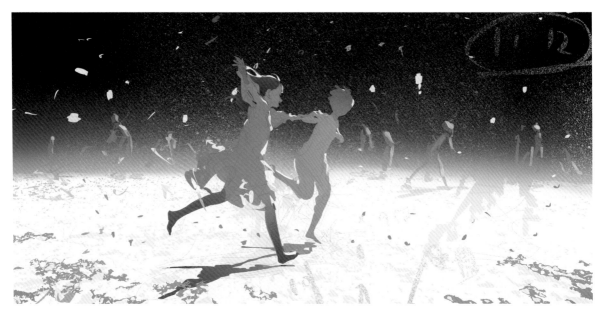

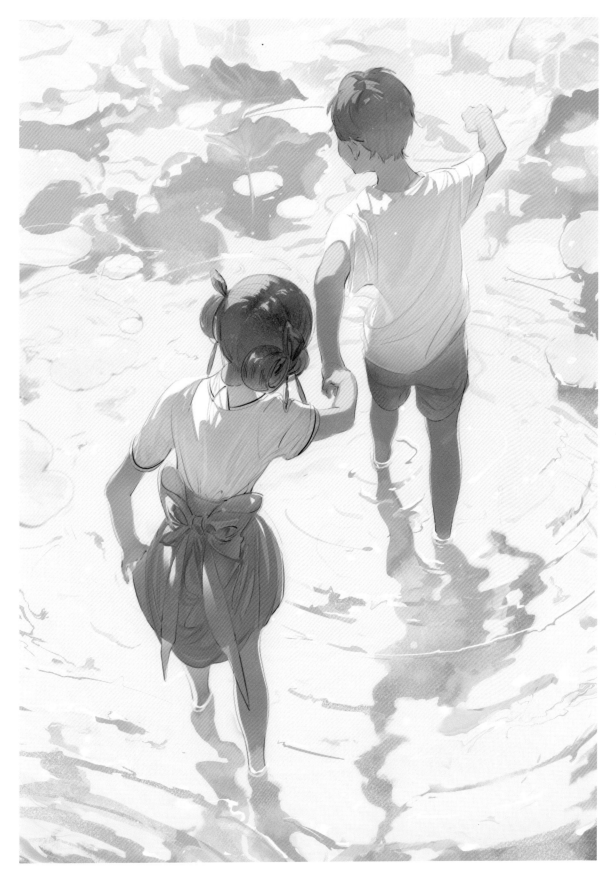

4. ロータス │ Lotus

2. NICO　**3.** 違う季節 │ Different Seasons

邦乔彦

バンチャオエン｜bangqiaoyan

Based in: 中国｜China
Language: 中国語｜Chinese
E-mail: 2572895038@qq.com
Web: -

Twitter: bangqiaoyan2018
Instagram: bangqiaoyan
Weibo: bangqiaoyan（@邦乔彦）
Pixiv: 10746425
Tools: SAI

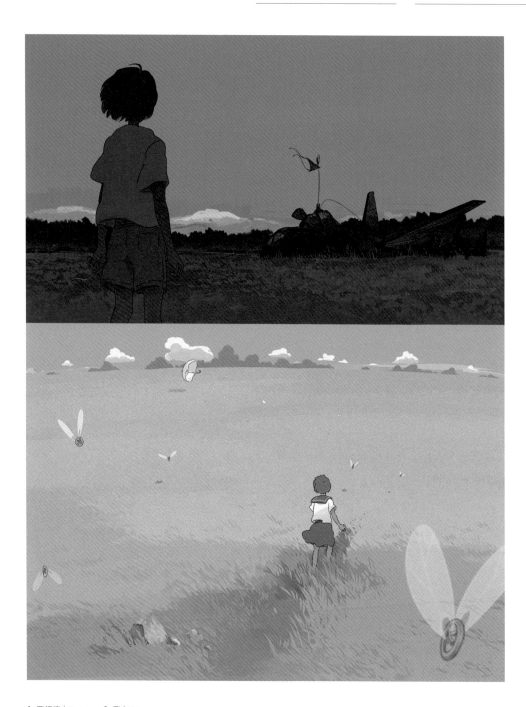

1. 飛行機｜Airplane 2. 飛｜Flying

Profile: 山羊座男子です。子供の時から絵が大好きで、これからも描き続けます。

I am a Capricorn. I have loved art since I was a little boy, and I will keep on drawing forever.

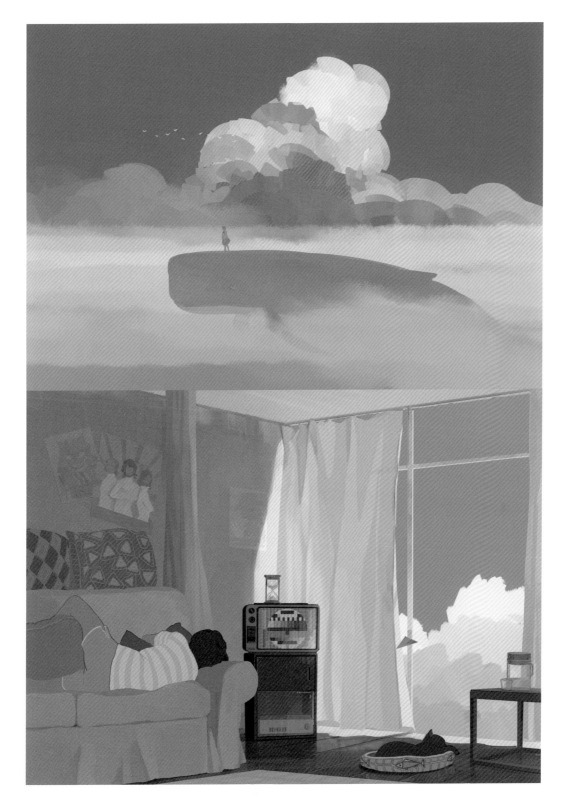

3. クジラ│Whale 4. 午後の青い空│Blue Sky in the Afternoon

Comment: 自分は静かな人間で、古いものや懐かしいものに惹かれます。音楽と絵を愛しています。音楽を聴くと頭の中に絵を想像する癖があります。創作は自分にとって、見ることができないものや憧れた場所を描くことです。自分の絵が見る人に幸せや希望をもたらすことを願っています。ありがとうございます。

I am a rather quiet person who is drawn to old and nostalgic items. I love music and art. When listening to music, I have this habit of imagining drawings in my mind. Creativity to me is depicting things I can't see with my own eyes or places that I am nostalgic for. I want my work to bring happiness and hope to those who view them. Thank you!

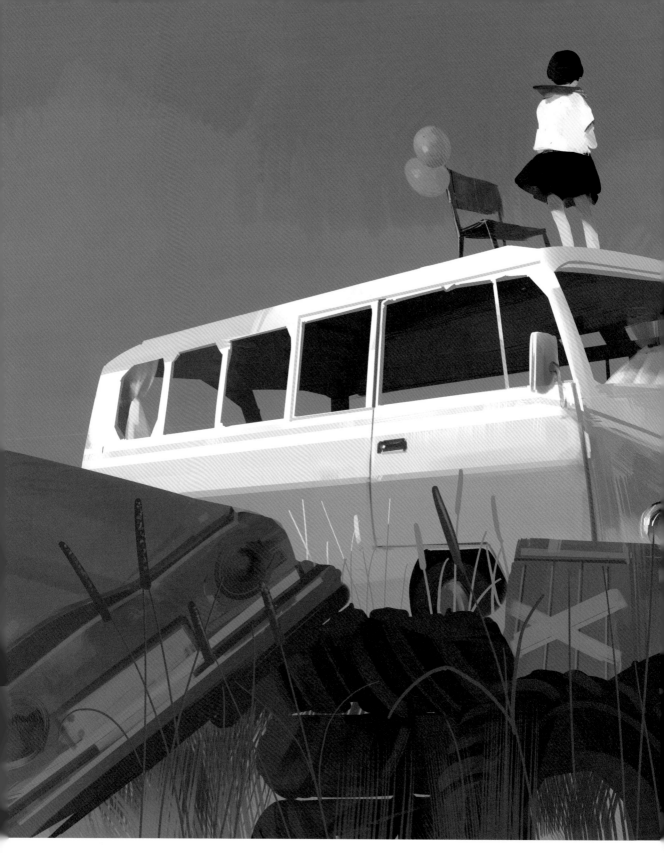

口袋巧克力

ポケットチョコレート | Pocket Chocolate

Based in: 中国 | China
Language: 中国語 | Chinese
E-mail: mhgyj@qq.com
Web: -

Twitter: Pocket_GYJ
Instagram: pocket_choco
Weibo: pocketcg（@口袋巧克力）
Pixiv: -
Tools: Photoshop / 优动漫 Paint / Cintiq 24HD

1.『昨日青空』挿絵 / 口袋巧克力 著 / 天聞角川 | Illustration for *Crystal Sky Of Yesterday* / written by Pocket Chocolate / Guangzhou Tianwen Kadokawa Animation & Comics Co.,Ltd

Profile: 1990年代に漫画業界に入りました。ペンネームの由来は「シンプルな幸せ」。これは憧れであり創作の方向性です。代表作『昨日青空』シリーズ、『もし、あの瞬間』などは、国家賞を複数受賞し、海外出版も多数。『昨日青空』アニメ映画は2018年10月26日中国全国で上映、自身も監修を担当しました。

I joined the manga industry in the 1990s. My pen name is inspired by "simple pleasures," which are what I dream of and what directs my creative work. The Crystal Sky of Yesterday series and *That Moment, Maybe* won many national awards and was published in multiple foreign editions. I also directed the animated version of *The Crystal Sky of Yesterday*, which was released in China in Oct. 2018.

2.『昨日青空』挿絵 / 口袋巧克力 著 / 天聞角川｜Illustration for *Crystal Sky Of Yesterday* / written by Pocket Chocolate / Guangzhou Tianwen Kadokawa Animation & Comics Co.,Ltd

3.『昨日青空：印刻流年』挿絵／口袋巧克力 著／天聞角川｜Illustration for *Crystal Sky Of Yesterday*: Sculpting in Time / written by Pocket Chocolate / Guangzhou Tianwen Kadokawa Animation & Comics Co.,Ltd

4. もし、あの瞬間 | That Moment, Maybe

Comment: 青春・思い出・日常に焦点を当て、人間性の真実と善、人生の美しさと希望を表現しています。伝統的な美術教育を受けてこなかった分、作風は二次元的ですが、作品の魅力が二次元の枠を超えて多くの読者に伝わり、喜んでもらえるよう、努力しています。

I focus on youth, memories, and daily life as I try to express the truth and goodness of humanity, and the beauty and hope of life itself. I received no art education, so my style is on the flat side, though I think its success in transcending two-dimensionality is what speaks to and delights so many fans.

王小洋

ワン・ショヤン｜Wang Xiaoyang

Based in: 中国｜China
Language: 中国語｜Chinese
E-mail: wxy.studio@qq.com
Web: -
Twitter: -
Instagram: wangxiaoyang.art

Weibo: wangxiaobear（@王小熊猫）
wangxiaoyangmanga
（@王小洋 Manga）
Pixiv: -
Tools: 透明水彩｜transparent water-colors／鉛筆｜pencils／Photoshop CC

王小洋｜China｜142

Profile: 漫画家・イラストレーター・作家・ミュージシャン・旅人・青年芸術家。小学生で漫画雑誌デビュー。2007 年、中国最大の漫画賞「金竜賞」最高賞受賞。2012 年「阿比鹿」音楽賞受賞後、ギターを持って全国を旅して、長い旅で見た風景と思い出を絵に残しました。

Manga artist, illustrator, writer, musician, traveler, young Chinese artist. I debuted in a manga magazine during grade school and won the Golden Dragon Award, China's premium manga award, in 2007. After receiving the Abilu Music Award in 2012, I travelled around China with my guitar, drawing the scenery I saw and the things I experienced.

| 1 | 2 |

1. 最近は元気か？｜How've you been?　**2.** 子供の頃の帰り道｜Walking Home as a Kid

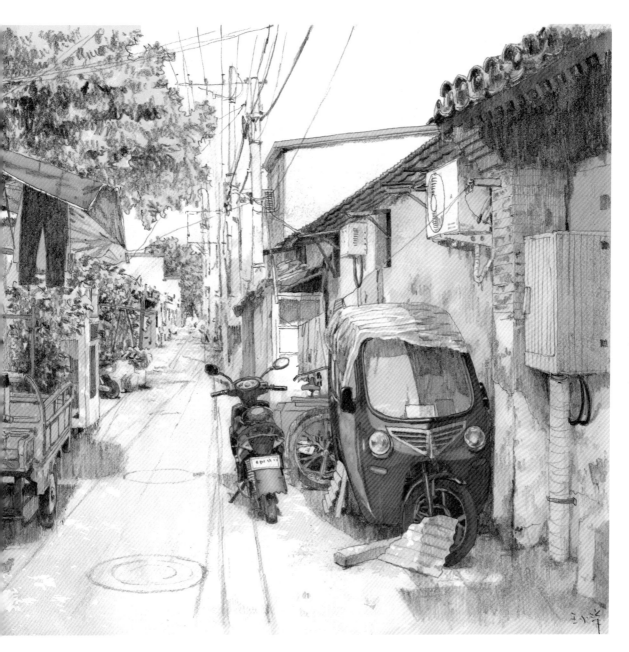

Comment: ペンを手にしてからずっと絵を描いていて、食事や睡眠と同じく自分の日常になっています。絵のおかげで、内向的な自分が一つの表現の手段を得ました。一人でも別の世界に行くことができます。君の絵は孤独で少し悲しい、でも優しいと言われたことがあります。きっとそれは自分の心の世界。一枚の絵は、一つの扉。描く人と見る人の世界を繋ぐ。本当に不思議ですね！

Ever since I first picked up a pen, drawing has been as much a part of my daily life as eating and sleeping. Being an introvert, art provides me a way of expressing myself, helping me enter a world of my own. People say my art is lonely and sad, yet gentle. I imagine the world inside my heart is the same. Each work is a doorway, magically connecting the worlds of artist and viewer.

4. 広州の夏｜Summer in Guangzhou

3. 南京の美齢宮の雨｜Rainy Day at Meiling Palace in Nanjing

李彬

リー・ビン | Bin Lee

Based in: 中国 | China
Language: 中国語 / 英語 / 簡単な日本語 | Chinese / English / Basic Japanese
E-mail: bin12345@foxmail.com
Web: -

Twitter: -
Instagram: -
Weibo: bin12345（@李彬 BinLee）
Pixiv: -
Tools: 水彩 | watercolors / Photoshop

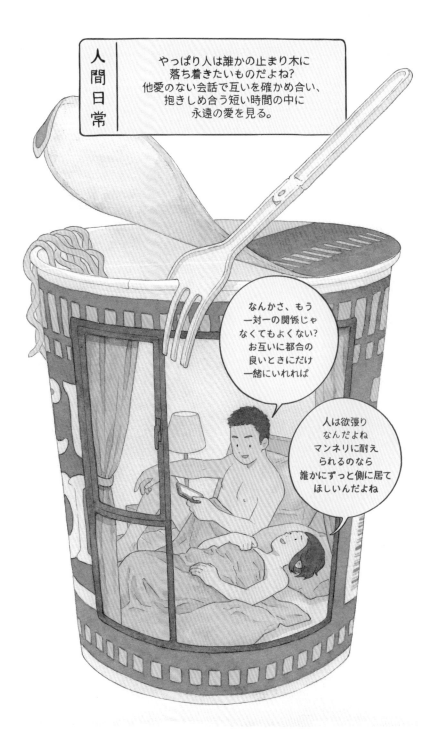

Daily Life

People just want to settle down on someone's perch, don't they?
They can imagine eternal love after a trifling conversation and a short embrace.

A: Hey, do we really have to commit to each other? What if we just get together when we need it.

B: People really are greedy. If they can stand being stuck with the same person, then they want them always by their side.

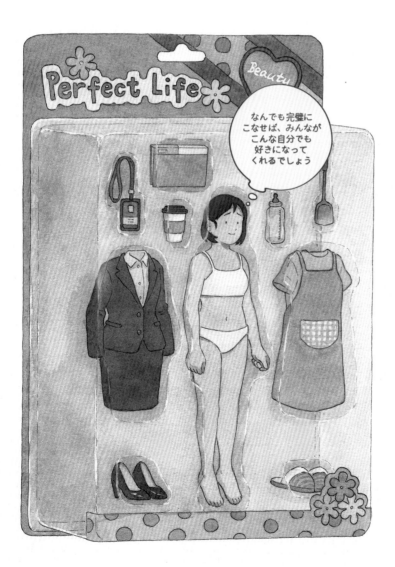

李彬｜China｜147

Daily Life

Having worn so many types of clothes and playing so many different roles, I forgot who I really am.

If I keep doing everything perfectly, then someday people will like even someone like me.

Profile: 子供向けイラストの仕事をメインにしています。アメリカで絵本『Together at Christmas』を出版（挿絵を担当）。近年描いた「人間日常」シリーズがネットで注目を集めました。最近は単行本化の出版準備をしています。新作絵本『星の王子さま』も今年発売します。

My focus is on illustrations for children. I was in charge of illustrations for the US publication of *Together at Christmas*, recently gained online recognition for my Daily Life series, and will soon publish a paperback book. My newest picture book, *The Little Prince*, will also be published this year.

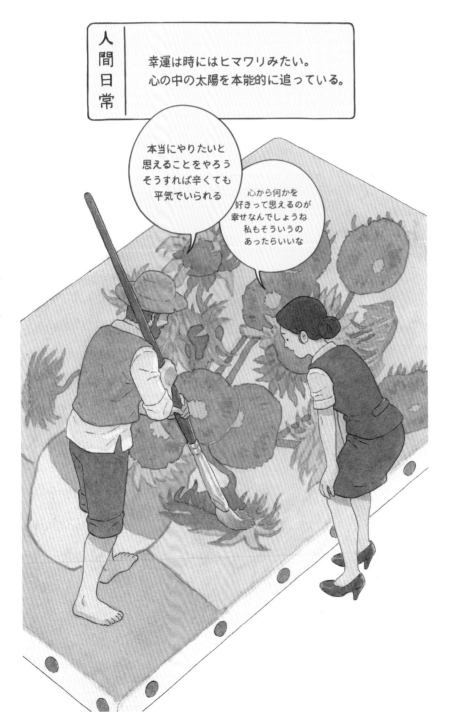

Daily Life

Good luck is like a sunflower; it instinctively follows the sun inside your heart.

A: If I do what I truly desire then I know I'll be alright, even when things get tough.

B: Loving something from the heart really is happiness isn't it. I wish I could experience that too.

Comment: 人生の美しさだけに限らず、より深く沈んで闇を観察しようとしています。皆さんの人生にも、人に話せない感情があると思います。悲しみ、悔しさ、困惑、焦り、後悔……。皆それぞれの人生や出来事を経験しているのに、同じような感情を体験します。これはある意味、人間の真の平等と言えます。闇を無視して得た光明に意味はない。多様な人間性を表現するのは難しいことですが、本当の創作の実感を得られます。

I observe both the beauty and the deep darkness of life. Sadness, frustration, confusion, impatience, regret. We each experience various life events, yet we share similar feelings and emotions. Perhaps this is the true equalizer among humans. Light obtained by ignoring darkness is meaningless. Depicting diverse humanity is tough, but it gives me a real sense of creation.

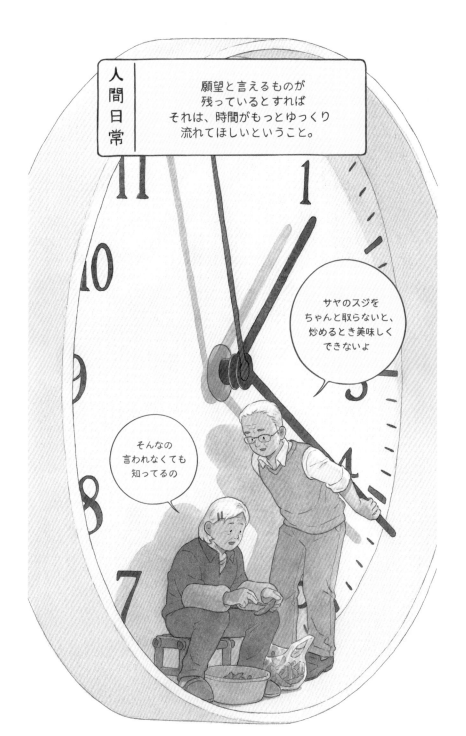

Daily Life

If you still have hopes, then the slow passing of time really isn't all that bad.

A: Make sure you completely remove the fibre of the shell, otherwise they won't be as good when you fry them.

B: I know that. You don't have to tell me.

北桥泽
ベイチャオゼ | BeiQiaoZe

Based in: 中国 | China
Language: 中国語 | Chinese
E-mail: 451075436@qq.com
Web: -

Twitter: -
Instagram: -
Weibo: beiqiaoze（@北桥泽）
Pixiv: -
Tools: 透明水彩 | transparent watercolors

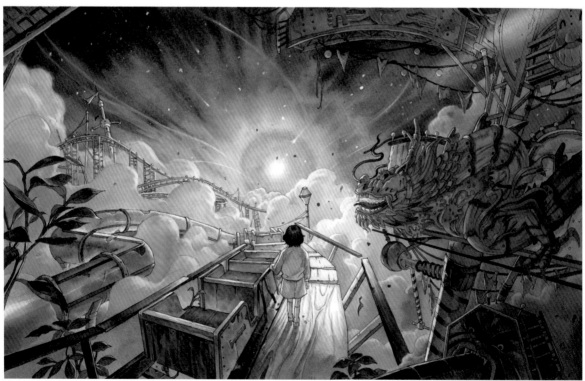

Profile: 広州美術学院を卒業。出版物にイラスト多数掲載。代表作は短編漫画『野孩子』、『傷逢』などがあります。

I graduated from the Guangzhou Academy of Fine Arts. My illustration has featured in a wide variety of publications. Among my representative works are the short manga collections *Wild Boy* and *Sorrowful Encounter*.

Comment: 絵を描くことは自分にとって、修行に近いと思います。　　　For me, drawing is like intensive spiritual training.

1	2	4
3		5

1. 2. 3. 4. 5.『野孩子』/ 雑誌「漫客・絵心 VOL.158」絵・北桥沢　脚本・明明真 / 知音伝媒グループ |
Wild Boy / TOUCH SOUL, VOL. 158 / illustrations by Beiqiaoze, script by Ming Ming / Zhiyin Media Group

苏小五

スゥ・シャウウ｜Litfive

Based in: 中国｜China
Language: 中国語｜Chinese
E-mail: suxiaowu1994@qq.com
Web: -

Twitter: -
Instagram: litfive1994
Weibo: suxiaowu1994
（＠苏小五 Litfive）
Pixiv: -
Tools: Photoshop CC

Profile: フリーランスのイラストレーター。漫画家。中国杭州在住です。

I am a freelance illustrator and manga artist living in Hangzhou, China.

1. 集合写真｜Group Photo　**2. 3.** 末日漫遊｜Final Day Journey

Comment: 未来のある日、私たちが持っている全ての価値が失われた時、新しい世界でどうやって生き残ることができるのか、ずっと考えています。自分なら、花と火と酸素と海水を持って、子どものように逃亡するでしょう。この逃亡の過程が絵になりました。

I have long wondered how humans will survive when the day finally comes when the day a new world finally arrives and destroys all of our existing values. I plan to flee like a child, with flowers, fire, oxygen, and seawater in hand. The process of that flight is what I depict in my art.

切尸红人魔

キシコウジンマ｜Seven

Based in: 中国｜China
Language: 中国語｜Chinese
E-mail: shane2018@qq.com
Web: -

Twitter: XseventhousandX
Instagram: x.seventhousand.x
Weibo: 2919608604（@切尸红人魔）
Pixiv: -
Tools: Photoshop CC

1. 無題｜Untitled

Profile: 漫画家、若手アーティスト。代表作は『紅色的皮』、『海門回声』です。

I am a young artist, active in manga. Representative works: *Red Angels* and *Sound of the Sea Gate*.

2. 無題 | Untitled

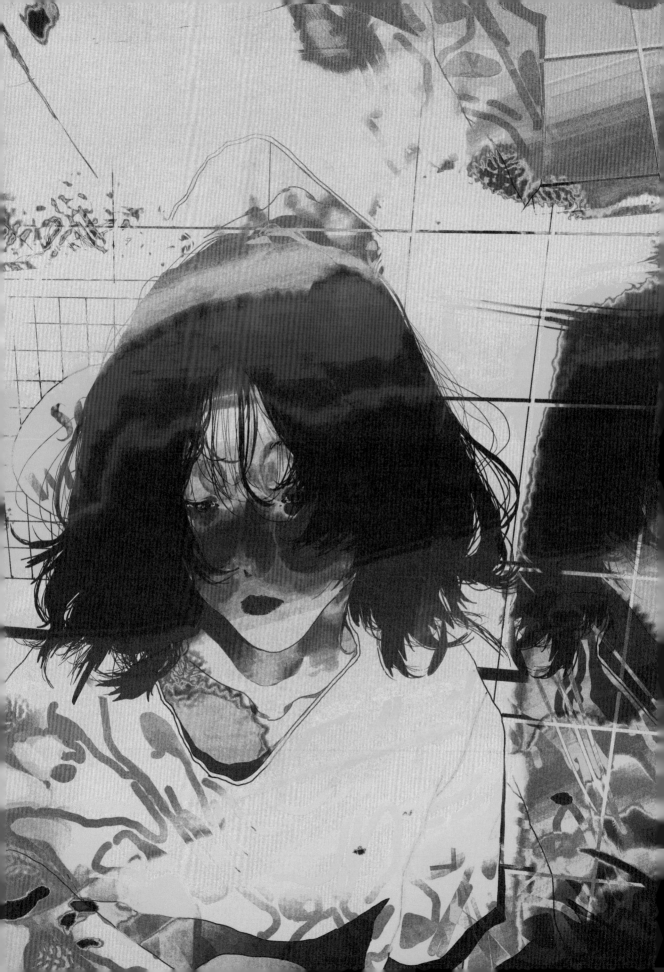

4. 5. 無題 | Untitled

3. 無題 | Untitled

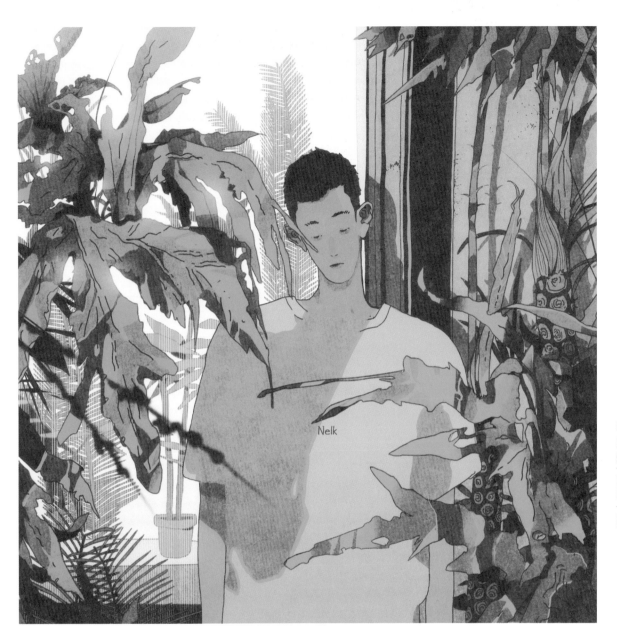

8. 無題 | Untitled

6.7. 無題 | Untitled

Comment: 自分の漫画は、体験から生まれたものが多いです。自分が一番詳しいのは自分自身のことですから。プライベートでは退屈な日常を送っていて、話し相手がいないので、頭の中で考えたことを創作に訴えるようになりました。漫画では、物語を語るよりも、意味のないものが好きで、言葉では言い表せない「雰囲気」を表現することに力を注いでいます。

Most of my manga are based on my own experiences, since the thing I know most is myself! My life is rather boring, with few chances for conversation, so my thoughts end up in my artistic creations. I prefer manga without deep meaning to those that tell a story, so I try to capture moods that defy expression in words.

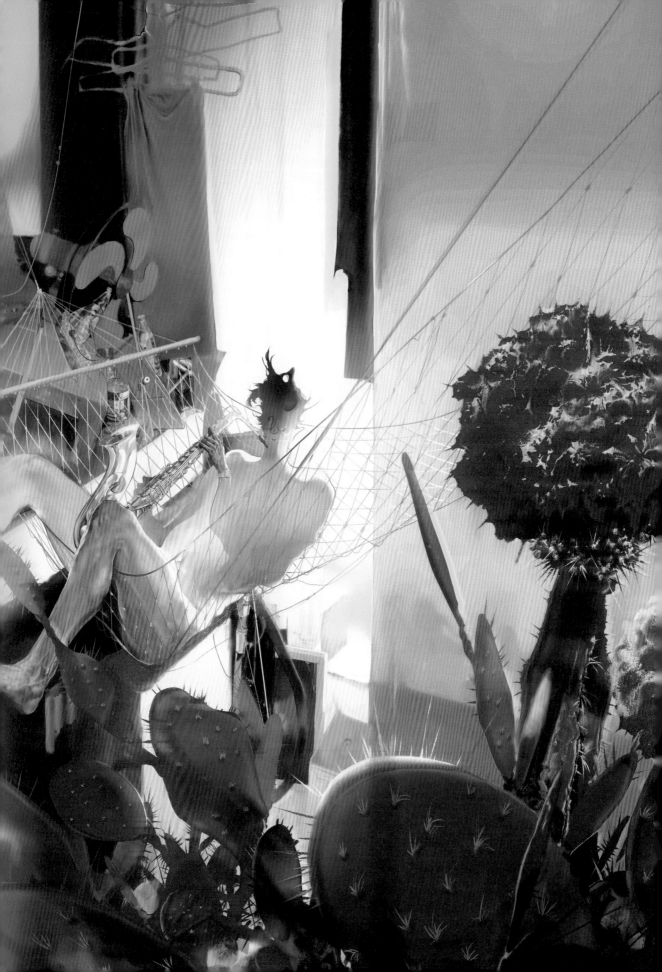

Special Works Created for *ASIAN ILLUSTRATION*

仙人掌 *Senninshō* by 切尸红人魔 Seven

仙人掌（ラフスケッチ）| Senninshō（rough sketch）

Comment

自分は強烈な色使いが得意でよく描いていますが、常に鮮やかな色で孤独を表現したいと思っています。今回の人物の描写では、体の輪郭を省略したので、その分体の内部をもっと細かく描き、その対比で肉体感を強調しました。皆ぜい肉のない筋肉質な肉体が好みだと思いますが、ぜい肉のある体のほうが大多数の真実を表していると思います。

Intense colors are my forte. I like expressing loneliness through bright colors. For this image, I minimized the human figure's outlines and focused instead on interior bodily details, creating a sense of physicality through that juxtaposition. Most of us prefer to see more muscle and less fat, yet I went for reality – the more common, plump physique.

低級失誤

サイテミス｜Saitemiss

Based in: 台湾｜Taiwan
Language: 中国語／英語
Chinese／English
E-mail: lucidmine@gmail.com
Web: https://www.facebook.com/dzmistake/

Twitter: -
Instagram: saitemiss
Weibo: -
Pixiv: -
Tools: Photoshop CC

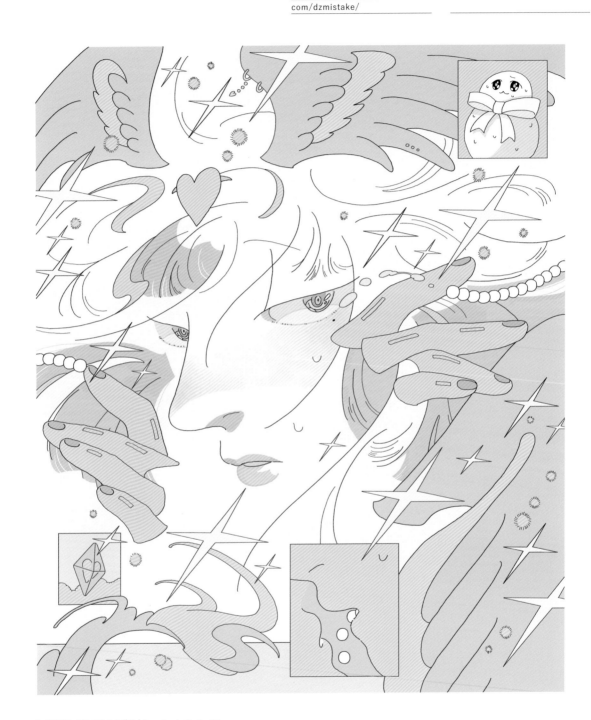

1. 天使だってそのために泣く｜Even Angels Cry for This

Profile: 現在台北在住。いろんなかわいい一瞬が好き。星座を研究することが好き。いろんなものが好き。真面目に話し合うことも好き。甘いのに塩辛い料理が嫌い。今はどんなものも嫌わないように心がけています。

I currently live in Taipei. I love discovering cute moments. I enjoy studying astrology. I like variety. I am into serious discussions. I dislike salt in sweet foods. Right now, though, I am trying not to hate anything.

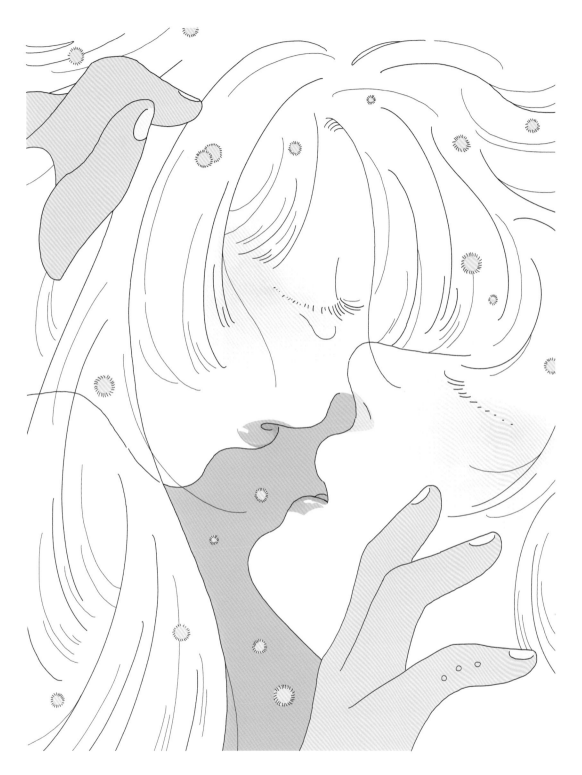

2. キス1つだけ？| Just One Kiss?

Comment: 2015年からイラスト活動を開始。毎年定期的に創作展覧会を開催。今、異なる素材を使うことに挑戦中です。例えば、絨毯、CDケース、合成皮革、シャワーカーテン、カラーアクリル…等と絵を結びつけます。少年少女、涙、恋愛感情といったものをコアにした、実験的な遊び場のようなものです。次に何が起こるのか、期待していてください！

I started illustrating in 2015. I have an exhibition of my work every year. Now I am trying new things, integrating materials like carpets, CD cases, leatherette, shower curtains, and color acrylics into my art. My work is an experimental playground spotlighting young men and women, tears, and romantic feelings. You never know what might happen next!

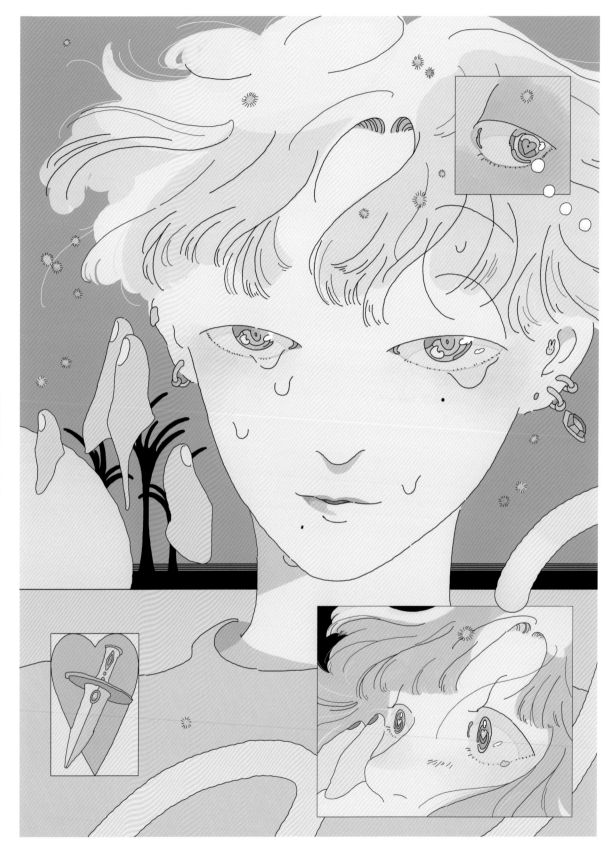

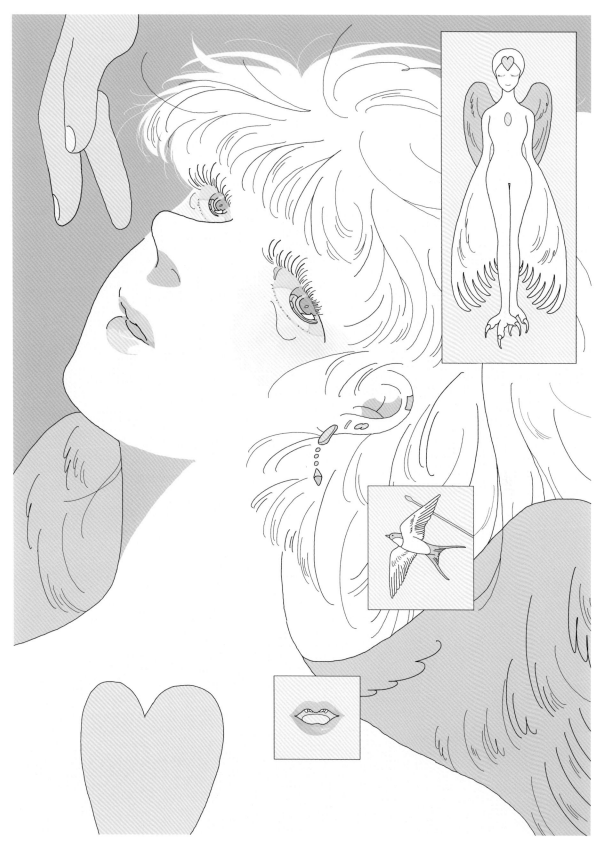

4. 進化前｜Pre-evolution

meyoco

メヨコ｜meyoco

Based in: インドネシア｜Indonesia
Language: 英語｜English
E-mail: meyocoart@outlook.com
Web: https://meyoco.art/

Twitter: meyoco_
Instagram: meyoco
Weibo: -
Pixiv: 7936571
Tools: Procreate / Photoshop CC / iPad Pro

Profile: 幻想的な要素のある可愛い服を着た女の子の作品を作ったり、可愛いアクセサリーやファッションをデザインしたりするのが大好きです。カリフォルニアのGallery Nucleusで作品展示。2020年5月に、初作品集『Polaris The Art of Meyoco』（PIE International）を出版しました。

I like drawing girls with cute clothing featuring fairy tale elements, and I also love designing cute accessories and fashion. I exhibit at California's Gallery Nucleus. The first book collection of my art, *Polaris the Art of Meyoco*, was published by PIE International in May 2020.

1		3		
2		4	5	

1. Transparent Jacket **2.** Bottles **3.** Moon Soda **4.** Medusa **5.** Sword and Tapioca

6. Floral Mermaid

7. Lovers of Lost Stars

Comment: 自分のイラストは、星や月、花柄など装飾的な要素を使うのが特徴です。これらの要素を加えて、服など一見普通のアイテムに魔法をかけるのが好きです。日本の漫画や西洋のアニメ、様々なアーティストから影響を受けました。特に影響を受けたのが、アルフォンス・ミュシャ、人気TVシリーズ『スティーブン・ユニバース』です。今後は、もっとオリジナル商品を作り、作品集を出したいです。

My works feature decorative elements like stars, moons, and flowers. I love working my magic on daily items like clothes. I am influenced by artists in many fields, including Japanese manga and Western anime, in particular Alfons Mucha and the hit TV series *Steven Universe*. In the future, I hope to produce evermore original work and someday collect my work into another book.

M-Y 蚂蚁

マイ｜M.Y

Based in: 中国｜China
Language: 中国語 / 英語 / フランス語
Chinese / English / French
E-mail: chenzuerrose@hotmail.com
Web: https://www.zuerchen.com/
Twitter: MYMAYI

Instagram: m.yillustration
Weibo: 2115545253 (@M-Y 蚂蚁)
Pixiv: -
Tools: 透明水彩 / 墨 / 顔彩｜transparent watercolors / sumi (ink) / Japanese watercolors (*gansai*) / Photoshop / InDesign / Illustrator

1. 東方魔法使い｜Witch of the East

Profile: イラストレーター・グラフィックデザイナー・アートディレクター・キュレーター。フランスで10年暮らし、今は中国で活動しています。絵は水墨と水彩をよく使います。グラフィックデザイン、スペースアート、建築、演劇、ファッション等、幅広い分野から着想を得ています。

Illustrator, graphic designer, art director, curator. After 10 years in France, I am now based in China. Most of my artwork is done in inks and watercolors. I am inspired by various fields, including graphic design, spatial art, architecture, theatre, and fashion.

2. 東方魔法使い│Witch of the East

Comment: グラフィック専攻の影響で、構図・バランスに興味があります。物語が好きで、作品の背後の世界を探求しています。頭の中には色々な世界観があって、イラストにもっと価値をつけたいと思っています。例えば、絵の背後に物語を広げ、漫画や絵本にしたり、リアルのイベントやプロダクトにしたり。絵は種のようで、たくさんのジャンルへ枝葉が伸びていき、本当に楽しいです！

As a graphics specialist, I am interested in composition and balance. I love narrative and exploring the world behind each work. I have many ideas in my head about how to flesh out my work in new ways, like expanding them into manga, picture books, real events, and products. Art is like a seed—it branches out and grows leaves in many genres, making life more fun!

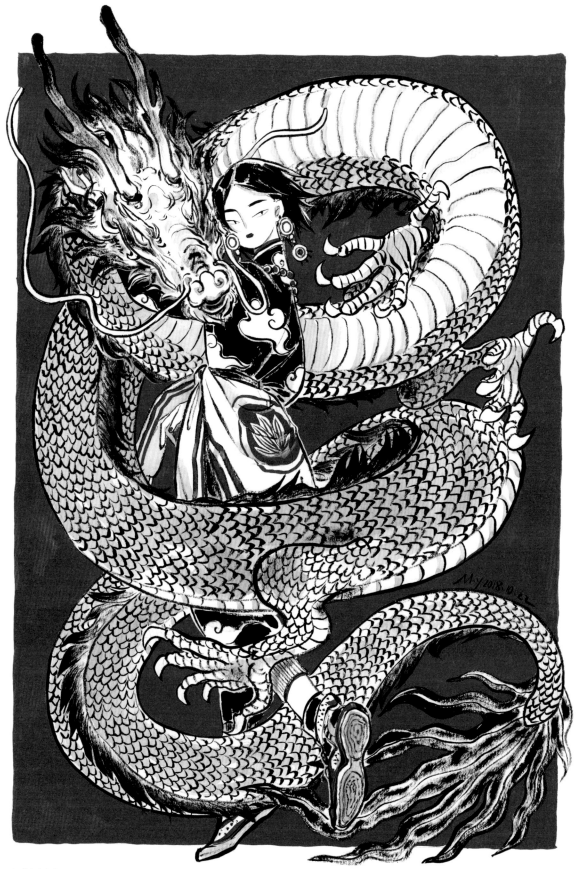

3. 龍と少女 | Dragon and Young Girl

4. 鳳羽の花│The Phoenix Flower

나무 13

ナム 13 │ TREE13

Based in: 韓国 │ Korea
Language: 韓国語 / 日本語
Korean / Japanese
E-mail: lyh09533@gmail.com
Web: -

Twitter: __tree_13
Instagram: __tree_13
Weibo: -
Pixiv: -
Tools: iPad / Procreate / Photoshop CC

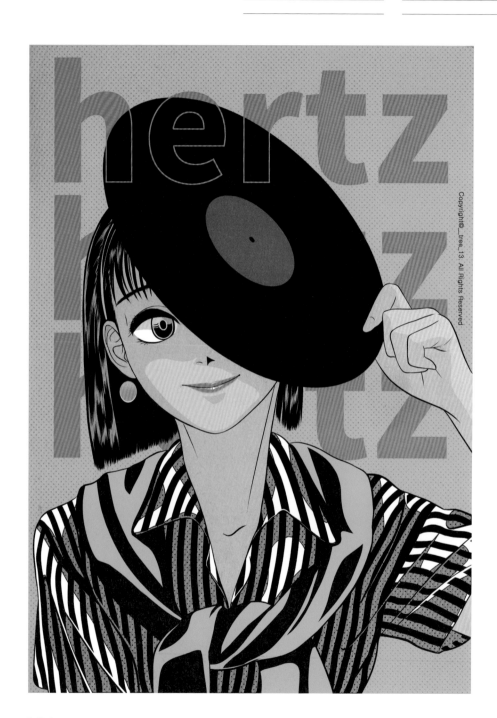

1. Hertz

Profile: フリーランスのイラストレーターです。代表的な展示は、「PRINTPRINTSSSSS」（2019）、「PLACEBO」（9AND BUNKER / 2019）、「New gravity_air」（Galerie LE MONDE / 2020）。『ILLUSTRATION 2020』（翔泳社 / 2019）に作品を掲載しています。

Freelance illustrator. My work has been featured in exhibitions, including PRINTPRINTSSSSS (2019), PLACEBO (9AND BUNKER, 2019), and New gravity air (Galerie LE MONDE, 2020), as well as in *ILLUSTRATION2020*, published by Shoeisha in 2019.

MINIMUM

NIKE TURTLE NECK
나이키에서 나온적은 없지만
그냥 나무13의 소망을 담았다
당신의 목에 감기는
부드러운 소재감이 일품
또한 잘 늘어나지 않는다!
가격 미정. NIKE

CHANNEL
波紋
SHOCK WAVE

lo-fi music only
ch.SHOCK WAVE

이런 채널이
있을리가없으니
안심하시고
그림을 즐겨주십시오

MAGAZINE
VITA MIINIMUM
19F/W ALL THAT RETRO
Aesthetic will save you

TREE13 ZEBRA HIGH WAIST
마치 교련복을 떠오르게 한다
테이퍼드 핏으로 떨어지는
바지의 형태가 넉넉해 보인다
가격 미정. TREE13

TREE13 SHORT TRUCKER JACKET
비비드한 컬러감으로 시선을 사로잡는
짧은 기장감의 트러커 재킷.
그대에게 언제나 에스테틱의 힘을 불어넣어 준다.
일단 입어나 보시라.
가격미정. TREE13

MINIMUM
Vita

GREENLIGHT SUMMER. ©

4.「Showa Idols Groove vol.02」アルバムカバー | *Showa Idols Groove Vol. 02* album cover / Night Tempo

SOUND

SOUND:*ROUND*

5. Sound Round

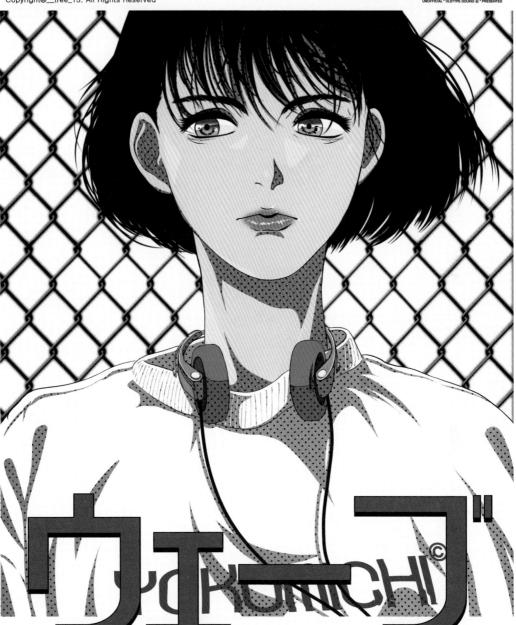

YOKOMICHIWAVE

6. Yokomichi Wave 2

Comment: 韓国や海外のサブカルチャー全般とミレニアム以前の世紀末コンテンツ
から、大きな影響を受けました。洗練されていない、過渡期的な面影
があらわれたその時代特有の魅力を、インスタントでエキゾチックに表
現できるよう、努力しています。自分が好きな世界を多くの人に共感し
てもらえたら嬉しいです。

I have been heavily influenced by both South Korean and foreign
subculture, as well as apocalyptic stories and images from the end
of the 20th century. I strive to give instant and exotic expression to
the distinctive appeal of the unrefined, transitional features of that
period. I would be thrilled to find many others that empathize with
my unique world.

정현

ジョンヒョン│Jeonghyeon

Based in: 韓国│Korea
Language: 韓国語／英語
Korean / English
E-mail: 47eaee@gmail.com
Web: -

Twitter: qt1_jo
Instagram: qt1_jo
Weibo: -
Pixiv: -
Tools: CLIP STUDIO PAINT PRO /
Photoshop CC

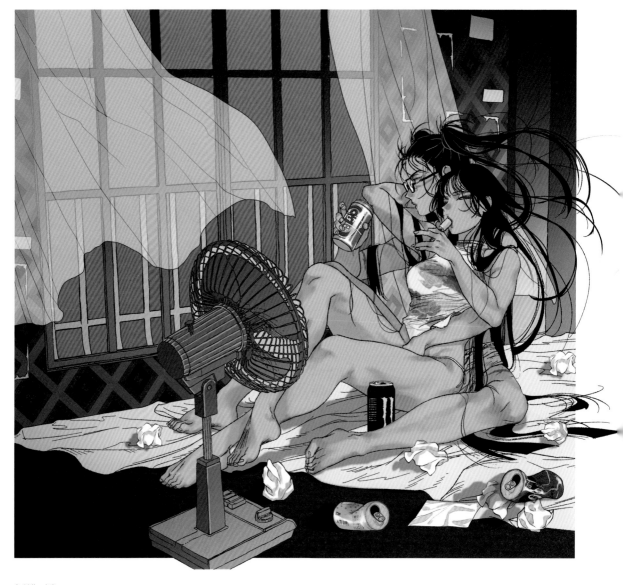

1. Killer Lilies

2. Killer Lilies

Profile: 韓国のアーティストです。イラストレーションとウェブコミック (Webtoon) の仕事をしています。現在、「Killer Lilies」の画集と、また別のGLウェブコミックを制作しており、2020年に公開される予定です。

I'm an artist based in South Korea. I've been doing illustrations and web comics for a while and currently am working on two projects. One is Killer Lilies, a collection of illustrations, the other is a girls love (GL) web comic which is going to launch in 2020.

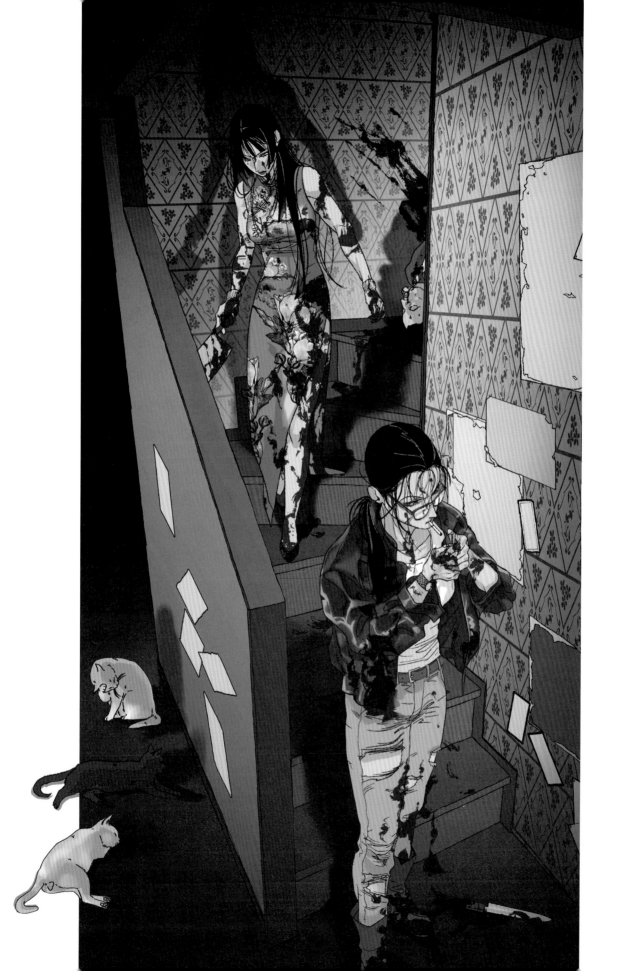

4. Summer

Comment: 彩度の高い強烈な原色とレトロな素材を使用し、魅力的なアジア女性のキャラクターを描くことに力を入れています。絵を見る人の好奇心を刺激するようなストーリーを、絵の中に込めたいと思っています。

Using intense primary colors with high chroma and retro-style subjects, I strive most of all to create captivating Asian women characters. I like adding stories to my pictures, in order to incite viewers' curiosity.

알페

アルベ | Alle Page

Based in: 韓国 | Korea
Language: 韓国語 / 日本語
Korean / Japanese
E-mail: paradise008@naver.com
Web: https://blog.naver.com/
paradise008

Twitter: sando_0
Instagram: -
Weibo: -
Pixiv: -
Tools: Photoshop CC 2018

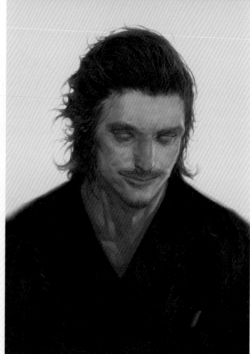

Profile: 幼い頃からゲームが好きで、ゲームを作る会社に就職するのが夢でした。幸いにも目標の会社に入社し、『Mabinogi Duel』『MARVEL Battle Lines』のイラストを描きました。現在はフリーランスでゲームイラストとウェブ小説の表紙などを描いています。

I loved video games as a child and longed to work for a video game company. I was fortunate to be hired by my dream firm, where I illustrated *Mabinogi Duel* and *MARVEL Battle Lines*. I currently freelance, drawing illustrations for video games and covers for web novels, among other projects.

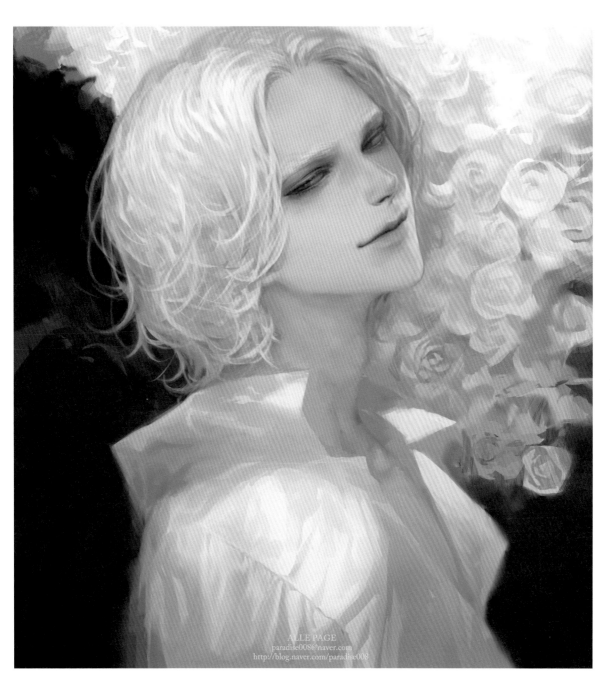

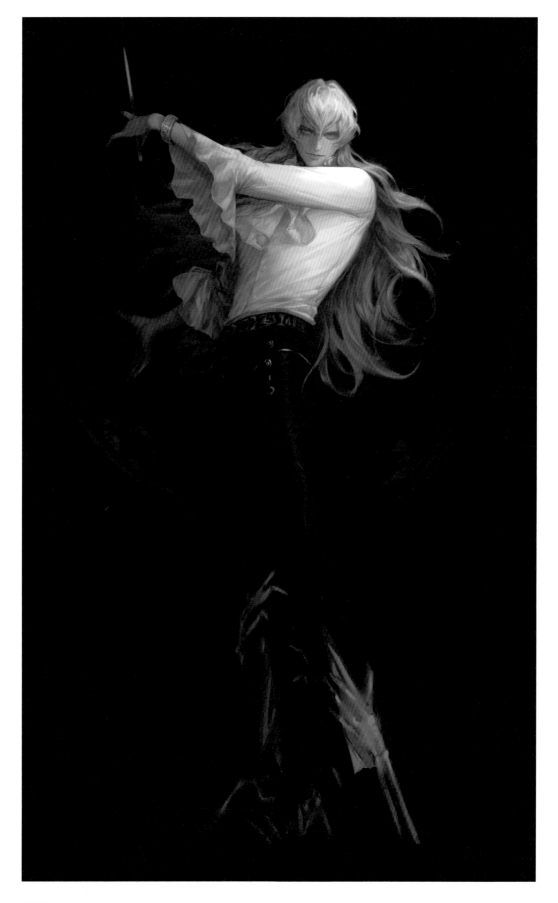

5. 無題 │ Untitled

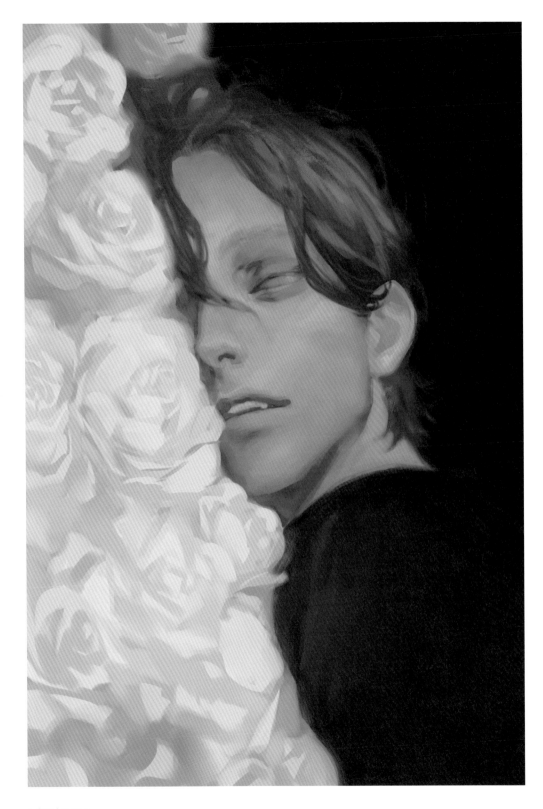

6. 無題 | Untitled

Comment: 主に彩度が低く穏やかな絵を描くのが好きです。感情が込められた顔の表情を描くのが好きで、髪の毛を納得がいくまで描くことにこだわるほうです。絵を描くときは、踏んだら砕けるような冬の落ち葉をイメージするようにしています。絵の中のキャラクターが息をして生きているかのような絵が好きなので、そんな絵が描けるように少しずつ努力しています。

I prefer to draw muted, tranquil pictures. I like drawing emotionally expressive faces and take my time getting the hair just right. When drawing, I imagine fallen winter leaves crunching beneath my feet. My ultimate goal is to draw characters who look so alive you would think that they are breathing.

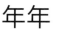

年年

ネンネン｜niannian

Based in: 中国｜China
Language: 中国語 / 日本語｜
Chinese / Japanese
E-mail: 150026410@qq.com
Web: -

Twitter: ninnin012044
Instagram: ninnin0120
Weibo: ninnin0120 （@年年 0120）
Pixiv: 13072637
Tools: Photoshop / Procreate /
Illustrator

1. カゲロウ｜Mayflies

Profile: イラストレーター。『N. 世界』『夢見市』など個人画集や絵本を7冊出版しています。中国の人気文芸雑誌「最小説」や数多くの小説の表紙を担当。日本の文芸レーベル、講談社BOX元編集長（現・星海社代表）太田克史氏に「正真正銘の天才」と評されました。日本で2年間生活して帰国。最近はコスメ、アパレル、文房具ブランドなどとコラボしています。

As an illustrator, I have 7 publications, including *N.world* and *Cypher's Chapel*, and create covers for novels and Chinese literary magazine *ZUI Novel*. I was honored by former Kodansha editor Katsushi Ohta's description of me as "a true genius." After 2 years in Japan, I returned to China and now collaborate on brands in cosmetics, apparel, and stationery, etc.

Random Romance

Comment: 自分は「水中の記録者」に過ぎません。ペンを持つたび、一人で水中へと沈んでいき、水の上の時間と感情を記録します。水の上にいるときは、自分は「テセウスの船」のままでいたいと思っています。自分を構成する様々な要素は置き換えられても、自分であることは変わらない。自分としてのアイデンティティを保ちつつ、置き換えられることによって、世界と一つになります。

I'm simply an underwater recorder. Whenever I pick up my pen, I become submerged in water (my work), recording my time and feelings experienced "above water." When I break the surface and reenter the real world, I strive to remain a "Ship of Theseus." Even if the elements that I am composed of become rearranged, I remain the same. While preserving my identity, I can become transposed and unite with the universe.

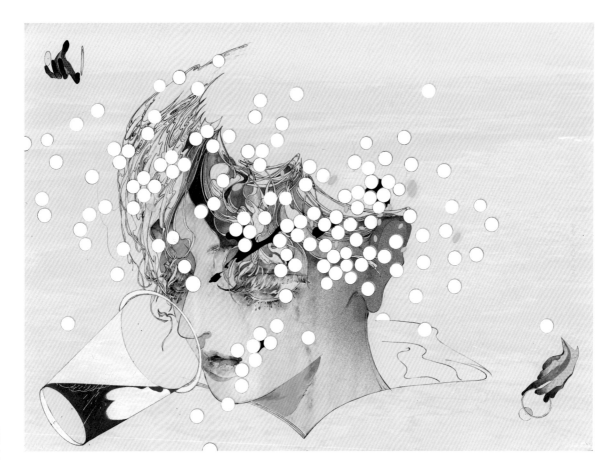

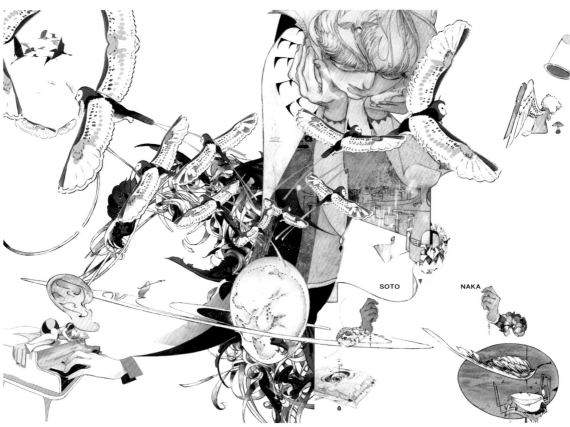

SOTO　NAKA

2. 紙コップ｜Paper Cup　**3.** 耳海｜Ears in the Sea

4. 6月のアリス／「最小説」2007年6月号カバー／最世文化 | June Alice / cover of ZUI Novel 2007 June edition / ZUI Culture

羅雨時

ラウジ｜luoyushi

Based in: 中国｜China
Language: 中国語｜Chinese
E-mail: luoyushi1993@gmail.com
Web: http://luoyushi.com/

Twitter: emg1993
Instagram: luoyushi1993
Weibo: emglory（@羅雨時）
Pixiv: 3311012
Tools: SAI

Profile: フリーランスのイラストレーター。趣味で漫画を描いています。

I am a freelance illustrator and create manga as a hobby.

1. フルーツキャンディ｜Fruit Candy　**2.** 分野｜Realm　**3.** ブランコ｜Swing　**4.** 雪積もる地面｜Snowfield　**5.** 初恋｜First Love

Comment: 歴史的、文化的要素があふれているイラストに惹かれています。今後も この方向で作品を作れるように頑張りたいと思います。

I am really drawn to illustrations with historical and cultural elements. I strive to integrate these elements into my own work as well.

法吉特

ファジット | forget

Based in: 中国 | China
Language: 中国語 | Chinese
E-mail: undoomsday@163.com
Web: -

Twitter: Forget2018
Instagram: -
Weibo: 1096164814（@法吉特）
Pixiv: -
Tools: CLIP STUDIO PAINT PRO /
Photoshop CC

法吉特 | China | 194

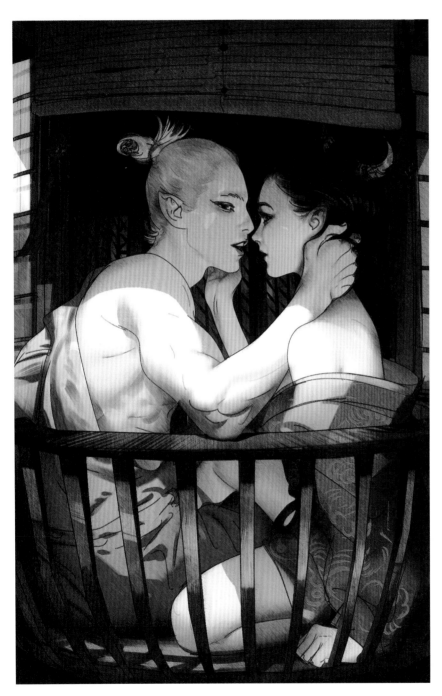

Profile: 14歳で漫画家デビュー。今年まで20年描き続けました。代表作『長生塔』『風的追記』『魔女安戈』『艾紗的森林』『隠山夢談』。繊細な少女からリアリティのある男子まで様々なキャラクターを描いています。

I debuted as a manga artist at the age of 14, and have been illustrating for 20 years now. My most important works are *Changsheng Tower*, *The Wind*, *Witch Ango*, *The Forest of AISHA*, and *Dream of the Hidden Mountain*. I create all sorts of characters, from delicate young girls to very realistic men.

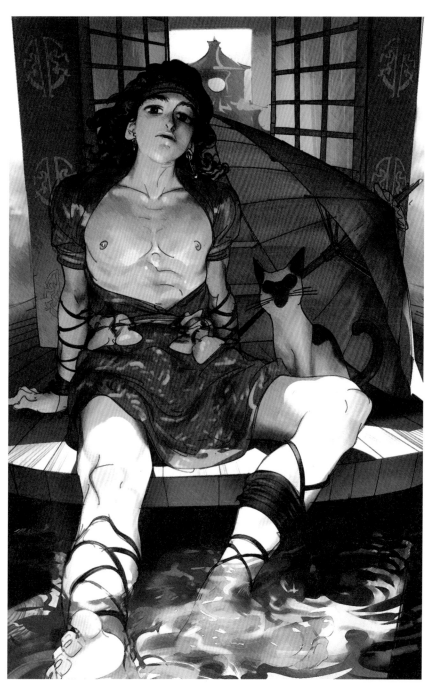

法吉特 | China | 195

Comment: ダークな作風が好みで、好きな漫画家は冨樫義博さん、伊藤潤二さんです。一番楽しいことはエネルギーが満ちている時に創作することです。作風や品質に対し人生をかけて追求し続けます。

I like dark styles, like those of manga artists Togashi Yoshihiro and Ito Junji. I am happiest when I am fully energized and creating manga. I continue dedicating my life to furthering the style and quality of my craft.

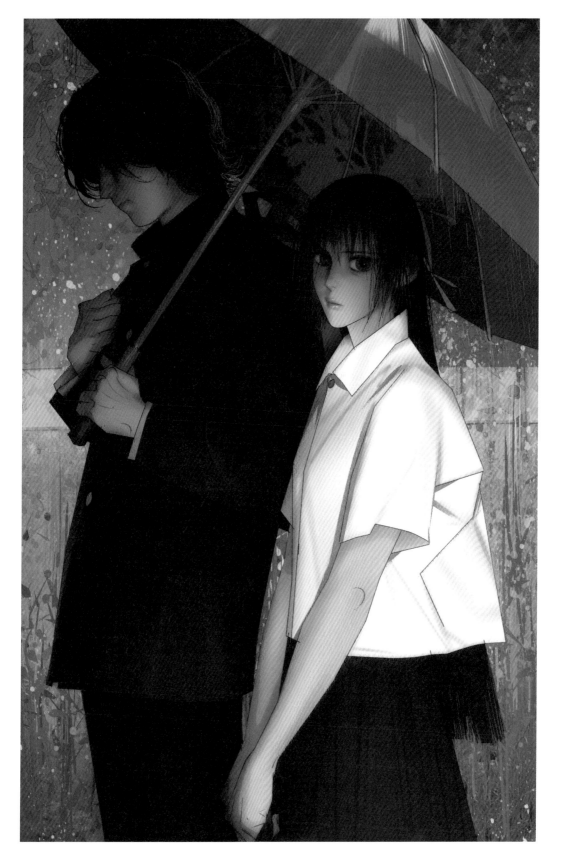

5. 無題 ｜ Untitled

4. 無題 ｜ Untitled

何何舞

ホホウ｜Eno.

Based in: 中国｜China
Language: 中国語｜Chinese
E-mail: 622009725@qq.com
Web: -

Twitter: -
Instagram: -
Weibo: hehewu (@何何舞)
Pixiv: -
Tools: 水彩｜watercolors /
Artstudio / Photoshop CC

Profile: 四川美術学院出身。大学時代から投稿を始め、雑誌で漫画デビュー。その後、イラストレーターとして活動。今は小説のカバーイラストや挿絵、映画・ドラマ・ゲームの宣伝イラストを中心に仕事をしています。

I started submitting manga as a student at the Sichuan Fine Arts Institute, which led to my eventual magazine debut. After graduation, I became an illustrator. Currently, my work includes cover art and illustrations for novels, as well as advertisements for movies, TV dramas, and video games.

1	3
2	

1. 鎮魔曲｜Demon Seals　**2.** 青い蛇｜Blue Snake　**3.** 小説『花鏡』カバーイラスト / 滄月 著 / 万巻出版｜Cover Illustration for *Flower Mirror* / written by CANGYUE / ECN Books

Comment: 水墨画タッチの手描きがメインで、最近は光と陰の理解が深まりました。手描きの質感と光と陰のストーリー性のある演出表現を取り入れたいと思っています。

While I mainly paint by hand, using a ink brush touch, I am currently trying to gain a deeper understanding of light and shadow. I would like to start creating images that stage stories through those combined formal features.

飞行猴

フェシンホオ｜Chen Feng

Based in: 中国｜China
Language: 中国語｜Chinese
E-mail: 982316092@qq.com
Web: https://cf3210.zcool.com.cn

Twitter: -
Instagram: -
Weibo: cf3210（@飞行猴CF）
Pixiv: -
Tools: Photoshop

1		3
2		

1. 2. 3. 無題｜Untitled

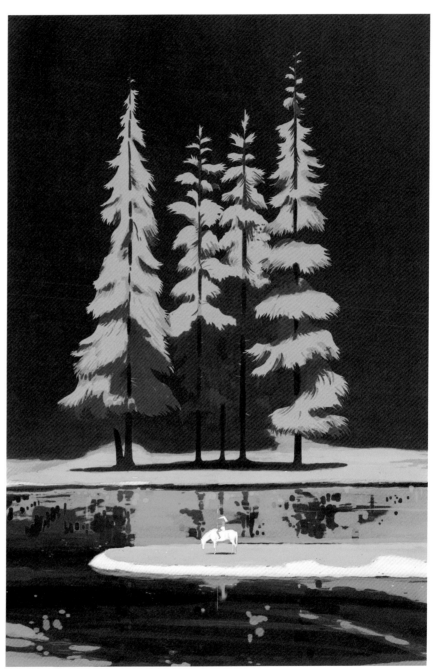

Profile: フリーランスのイラストレーターです。
Freelance illustrator.

Comment: 冒険を諦めず、人生を楽しむ。
I enjoy life, always seeking adventure.

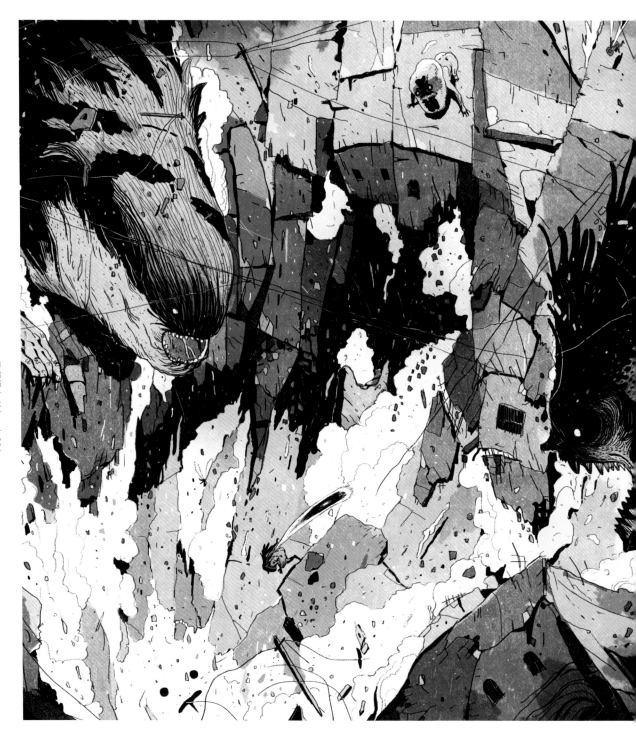

4. 無題｜Untitled

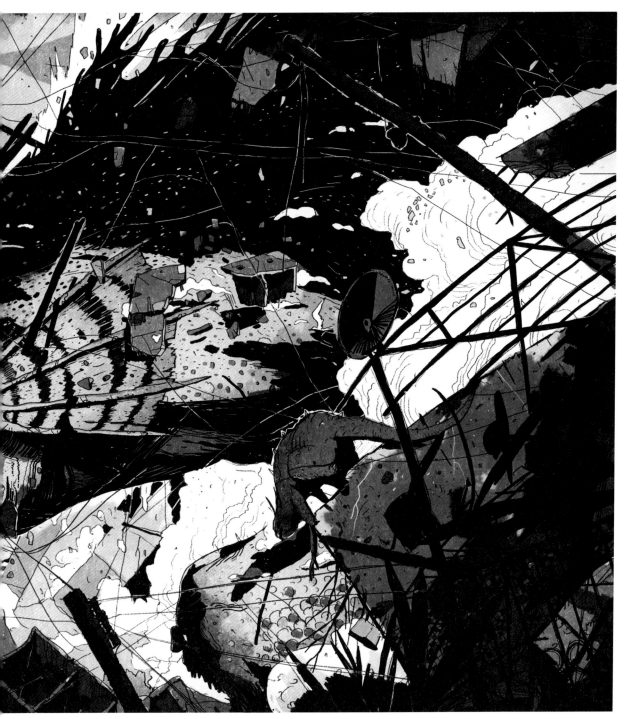

LOIZA

ロイザ｜LOIZA

Based in: 台湾｜Taiwan
Language: 中国語 / 日本語 / 英語
Chinese / Japanese / English
E-mail: jeff19840319@gmail.com
Web: https://www.facebook.com/loiza.chen/

Twitter: loiza0319
Instagram: loizachen
Weibo: －
Pixiv: 1415966
Tools: Photoshop CC

Profile: 台湾芸術大学書画芸術学部を卒業後、ゲーム会社で2D美術設定を担当。その後、個人コミュニティ「白書夜行」を経営し、出版関連の挿絵、美術、デザインアウトソーシングを受注するとともに、美術講師をしていました。現在はゲーム業界に戻り、『リーグ・オブ・レジェンド』でコンセプトアートを担当しました。

After graduating from the National Taiwan University of Arts, I created 2D artistic settings at a video game company, managed an online community called Day and Night, provided illustrations, artwork, and designs for outsourced publication projects, and taught art. I am now back in the game industry, working on *League of Legends* as a concept artist.

1	2

1. 隠兜の陣｜Hidden Team　**2.** 狐武者｜Fox Warrior

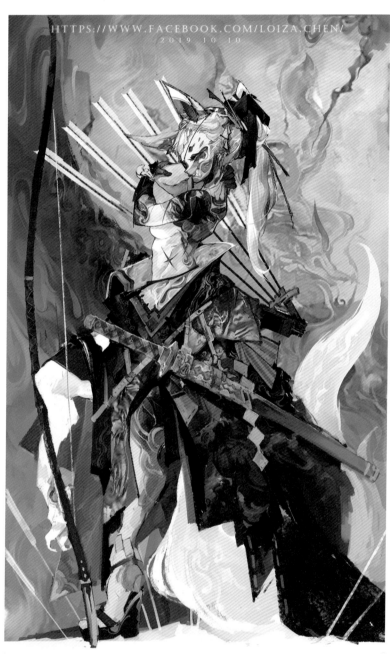

LOIZA | Taiwan | 207

Comment: 大学の書画学部で受けた影響が強く、私の作品の最も大きな特徴は、水墨画の雰囲気を帯びていることです。初期の作品は手描きが主でしたが、現在は仕事の関係上、CG創作に変更しています。ですが、CGでもやはり大量の手描き素材を使用していて、水彩の染色効果のある着色法がとても好きです。重度の狐好きなので、創作の題材には頻繁に狐系のキャラクターが登場します（笑）。

Due to having studied in a calligraphy and painting department in college, my style is heavily influenced by ink painting. The majority of my early works were hand painted, but I transitioned to CG for my job. Nonetheless, I still rely heavily on analog processes for my CG work, and prefer coloring methods that produce a watercolor look. As I love foxes, you will find many fox-like characters in my art!

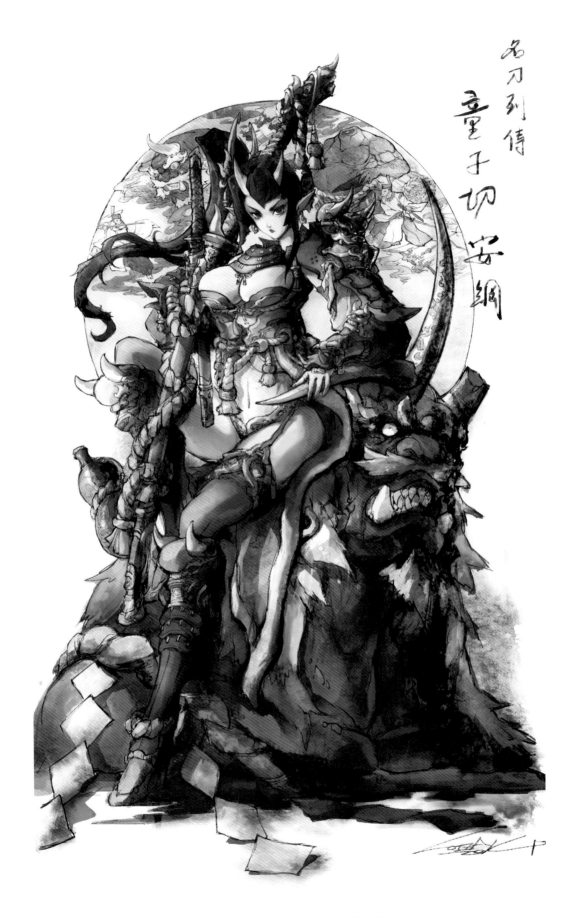

名刀列傳
童子切安綱

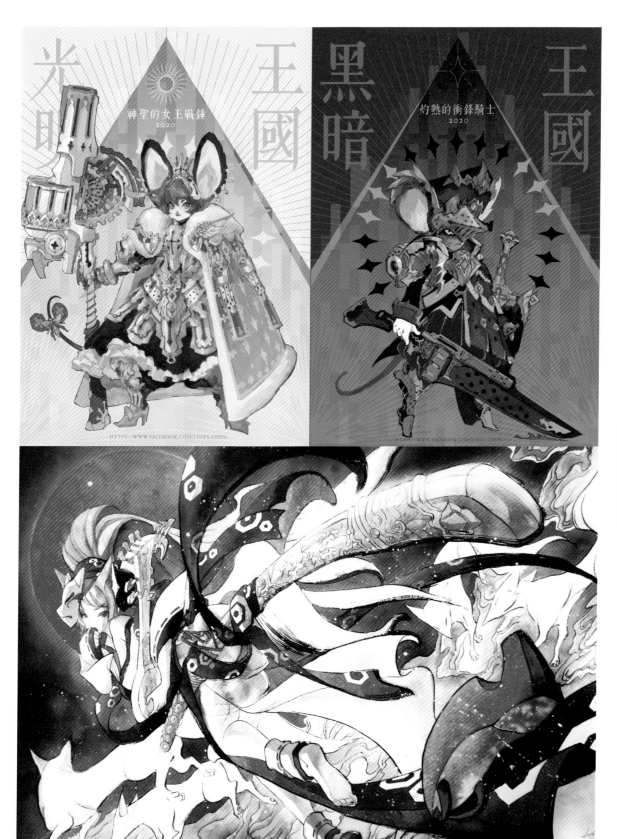

神聖的女王戰錘 2020

灼熱的衝鋒騎士 2020

	4	5
3		
	6	

3. 童子切｜Dojigiri Sword　**4.** 勇鼠英雄奇譚 - 賢王｜Rat Hero – Wise King　**5.** 勇鼠英雄奇譚 - 騎士｜Rat Hero – Knight

6. 稲荷神｜Inari, God of Agriculture

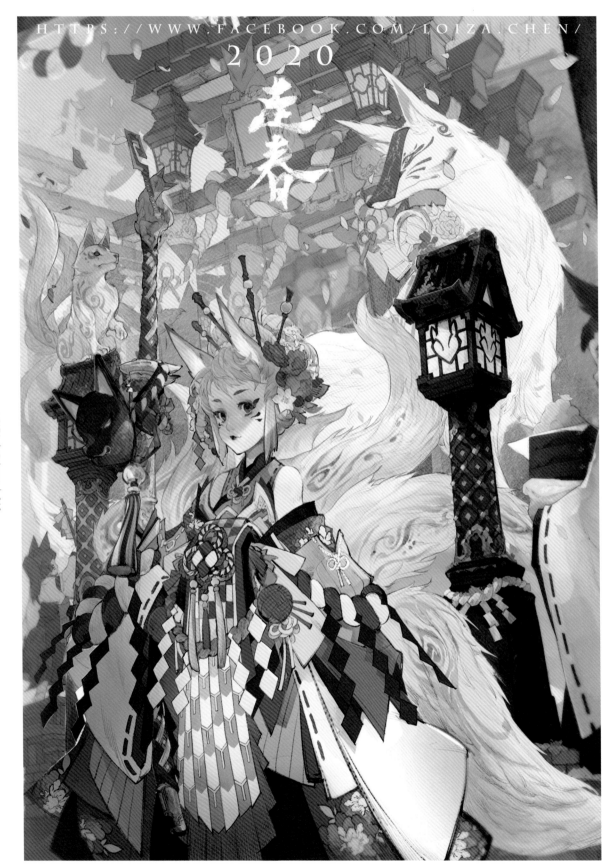

7. 新春のお出かけ｜New Year's Outing

HTTPS://WWW.FACEBOOK.COM/LOIZA.CHEN/
2019/10/29

死神

LOIZA | Taiwan | 211

8. 狐死神 | Fox Grim Reaper

Zeen Chin

ジーン・チン｜Zeen Chin

Based in: マレーシア｜Malaysia
Language: 英語｜English
E-mail: zeen@pirateshipstudio.com
Web: http://www.artstation.com/zeen

Twitter: zeen_chin
Instagram: zeenchin
Weibo: 5961164149 (@ZeenChin)
Pixiv: –
Tools: Photoshop CC

Profile: マレーシアのイラストレーター、コンセプトデザイナー。代表作は『Legend of the Cryptids』、『Galaxy Saga』、『Kingdom Death』のイラスト。2017年に初画集『返童』出版。独特の東方ファンタジー的な妖怪と、和風の色彩感覚が特徴です。

I am a Malaysian illustrator and concept designer. My representative works include *Legend of the Cryptids*, *Galaxy Saga*, and *Kingdom Death*. The first book collection of my work, *Re-Child*, was published in 2017. Fantastical East Asian demons and Japanese color sensibility characterize my work.

1. 米婆舗｜Witch Store **2.** 空｜Sky **3.** 傀儡｜Puppet

Comment: 創作テーマは、自分の日常からアイデアをもらっています。創作は生活の中から生まれるものだと思うので、自分の日常や体験から創作したほうが、より絵に専念することができます。

The subject matter of my art derives from my daily life. Since I believe that true creativity springs from one's personal experiences and daily life, that is what I focus on when making art.

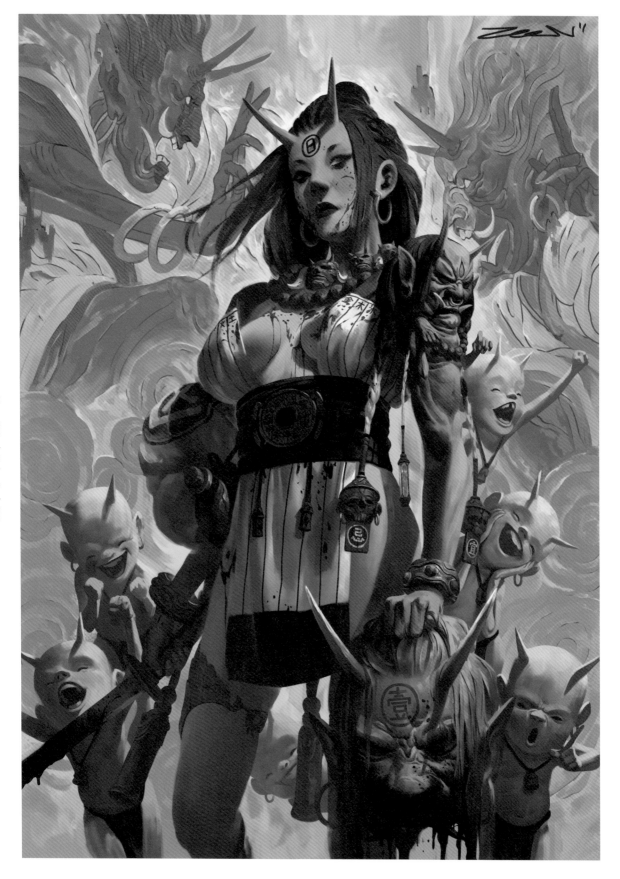

4. 月曜を殺し、日曜万歳 │ Kill Monday, Long Live Sunday

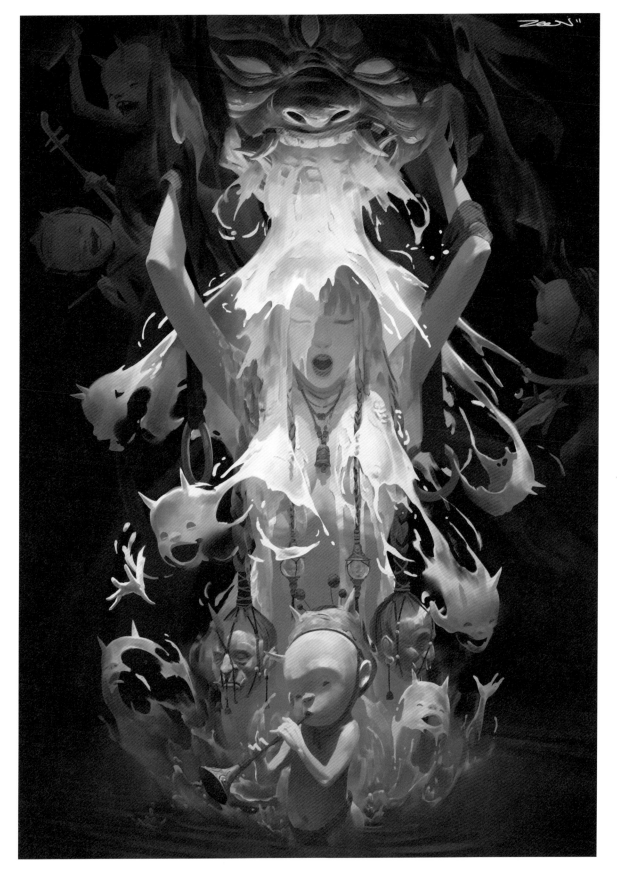

5. 淨魂曲 | Song of Soul

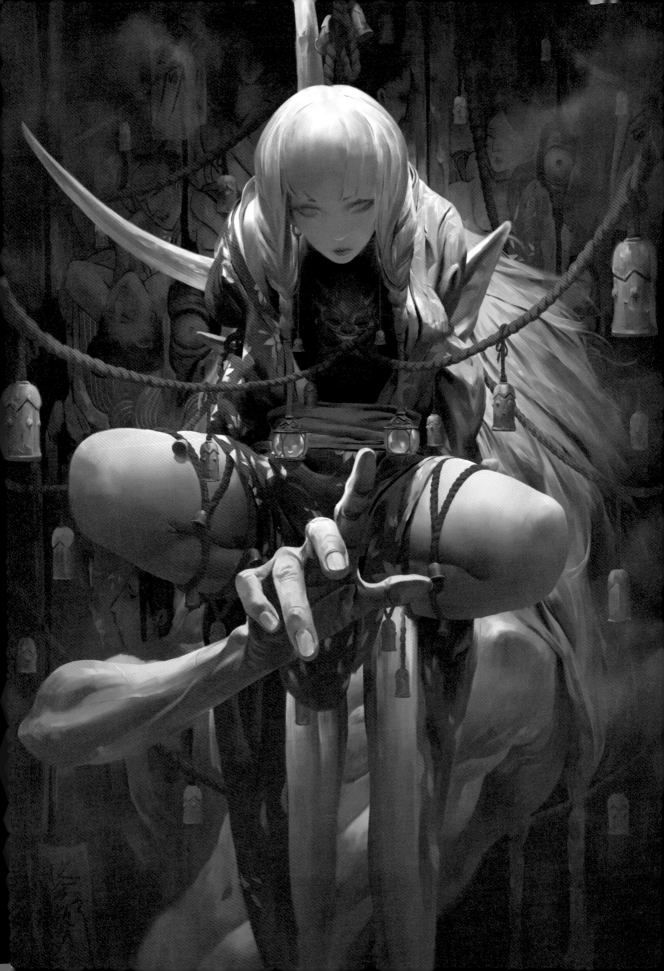

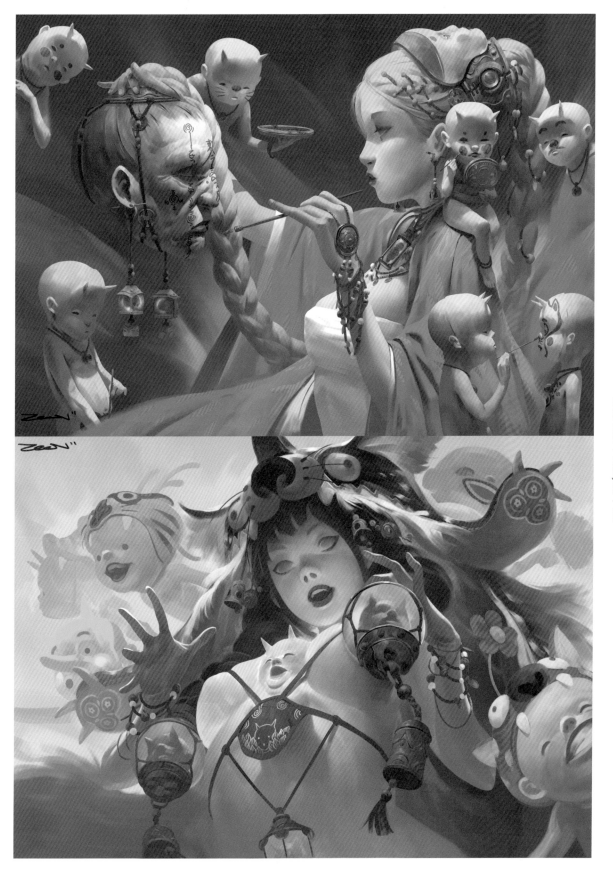

7. 畫譜｜Incantation　8. 童心｜Child Heart

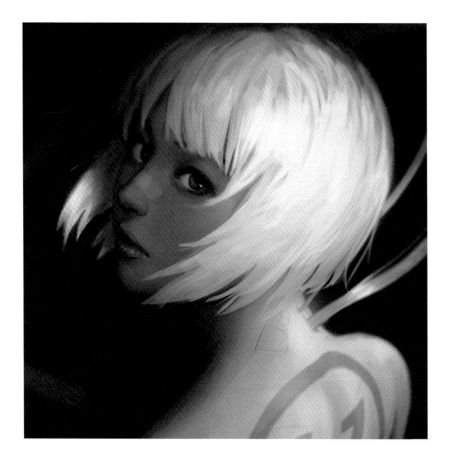

INTERVIEW:

GUWEIZ

圧倒的な画力を誇るシンガポールのイラストレーター、GUWEIZ。
クラウドファンディングで支援を募った自身初の作品集『Guweiz: The Art of Gu Zheng Wei』は、
キャンペーン開始後、たった半日で目標額を達成。
世界中にファンをもつ彼に、自身の絵のルーツや画力へのこだわりについて語ってもらった。

GUWEIZ—an artist of amazing talent hailing from Singapore.
His first self-published book, *Guweiz: The Art of Gu Zheng Wei*, reached its crowdfunding goal
within just half a day after announcing the campaign. GUWEIZ, who enjoys a global fan base,
discusses here his creative roots and his artistic philosophy.

Interview & Text：MUCHO

大学を辞めてプロになろうと決意 すべての時間を絵に注いだ

──絵を描き始めたのはいつ頃からですか?

子どもの頃から僕は教科書に落書きをするとか裏紙に棒人間を描くとか、そういうことが大好きでした。まあでも正直言うと、絵を描くことに対して興味を持ち始めたのは、やはり高校の時だと思います。かなり日本のアニメにははまってましたね。それがきっかけで自分も描いてみたい気持ちになりました。最初は鉛筆でネットの絵を模写したりして、描いてるうちにどんどん絵を描くことが好きになっていきました。

──GUWEIZさんが暮らしている国では、一般の方から見てイラストレーターという仕事はどのようなイメージでしょうか?

僕は小さい頃に親と一緒に上海からシンガポールに移住して、そこで育ったのでシンガポールのことしかわかりませんが……僕の経験だと、やはりシンガポールではアーティストは職業選択として頼りない印象ですね。お医者さん、弁護士、エンジニアなどのほうがイメージがいいです（笑）。皆さんもなんとなくイメージがあるかもしれませんが、シンガポールの教育競争は非常に激しいんです。政府と親はかなり早い段階から成績を気にしだします。3歳から塾に行かせるんですよ。一刻も早く成績のレースに参加させたいって、怖いですよね（笑）。こんな雰囲気だから、アートは趣味としか思われない。子どもの時から美術教育をさせる親はほんの一握り。学歴社会です。僕の意見としては、どの国に住んで、どんな学歴を持っていたとしても、自分の努力で練習を重ねることができれば、どんな環境にいても絵を描くことを仕事にできるんじゃないかと思っています。

──創作活動を始める時に、きっかけとなったアーティストや作品はありますか?

最初の頃は正直まともな美術教育を受けてこなかったので、ネットで好きな絵を見つけたら鉛筆を使って紙にコピーするだけでした。それでも普通に楽しかったです。日本のアニメーターの影響を結構受けたと思います。具体的にどの作品がきっかけかはちょっと決められないのですが、その頃は本当にたくさんアニメを見ていました。特に印象深い作品は「千と千尋の神隠し」、「天元突破グレンラガン」、「刀語」、「新世界より」、「新世紀エヴァンゲリオン」です。

──プロのイラストレーターになろうと決意したのはいつ頃からですか?

絵で食べていくことを決心したのが大学1年の前期でした。当時はもういくつもイラストの依頼があったので、毎日大学が終わったら家で深夜まで描いていたし、大学の勉強もしなきゃいけなかった。忙しすぎて回らない感じがしていたし、絵を描くことを仕事にするのは当時の自分にとってリアリティがあった。それで前期が終わった時退学しようと決めたんです。全部の時間を絵を描くことに集中させました。学歴を捨てて未知の道に踏み出す決心をするのはそんなに簡単ではなかったですね。親とおばあちゃん、自分も含めて皆が焦りました。でも結果、家族と友人は僕を応援してくれました。自分は幸運なんだなと思います。それからどんどんプロとして軌道に乗ったので、皆も完全に僕の決意を受け入れてくれました。

──プロになってターニングポイントになった仕事などはありますか?

率直に言うと僕の中のターニングポイントは、プロになる前だと思います。その頃はそんなに上手くないし、あまり注目もされていなかった。振り返ると、当時はただ有名なアーティストの影響を受けて、スキルと手法を真似していただけで、基礎がしっかりしていなかった。そんな時期にターニングポイントになったのが、初めて写真を模写して練習したことです。その練習でわかったのは、基礎の重要性でした。そこからは、実物の構造やパースから構図を考えるようになったんです。段々自分の作風を確立させていきました。

──仕事は常にストレスが伴います。GUWEIZさんにとってストレスとは? 落ち込んだ時期はどう対処していましたか?

Quitting college and spending all my time on art

Q. When did you begin drawing?

As a child, I loved to doodle in my textbooks and draw stick figures on scrap paper. To be honest, though, I truly didn't get into drawing until high school. I was really into Japanese anime. That is what inspired me to get started. I began by doing pencil sketches of things I saw on the Internet, and the more I drew, the more I liked it.

Q. What do people generally think of illustrators in your country?

My parents and I immigrated to Singapore from Shanghai when I was very young, so Singapore is all I've ever known. In my experience, though, Singaporeans see the life of an artist as an unreliable choice. Doctors, lawyers, engineers, and the like have a better image (laughter). As you probably imagine, academic competition in Singapore is extremely tough. The government and parents start focusing on school performance from early on, and kids are sent to cram school from age 3. It's pretty awful to enter the educational rat race at such a young age, don't you think (laughter)? With all that going on, art is just viewed as a hobby. Very few parents allow their children art education. It's a meritocracy. My own feeling is that, wherever you live, whatever the environment, as long as you put forth the effort and continue honing your ability, you can become an artist.

Q. Was there a particular artist or work that spurred you to enter that field?

To be honest, I didn't receive proper art education early on. I just copied pictures which I found on the Internet and liked. I really enjoyed just doing that. I feel like I was quite influenced by Japanese animators. I couldn't really point to any specific works which got me going, but I certainly enjoyed my share of anime in those days. I was particularly impressed by *Spirited Away*, *Tengen Toppa Gurren Lagann*, *Katanagatari*, *From the New World*, and *Neon Genesis Evangelion*.

Q. When did you decide to become a professional illustrator?

I decided that art would become my livelihood in the first semester of my freshman year at college. By then, I had already received several commissions, and I had to get my homework done even as I was burning the midnight oil to work on my art. It was more than I can handle, but drawing professionally was my true reality. When that semester ended, I decided to leave school and devote myself fully to art. The decision to abandon academics and follow an unknown path was not an easy one. My parents, my grandmother, and I were a bit panicked at first. In the end, my family and friends supported my decision. I feel I'm really fortunate for having that. Once I made up my mind and got on track to become a professional, everybody gave me their full support.

Q. Once you became a professional artist, was there a turning point in your career?

To be honest, I think my turning point came before I reached the decision to "go pro." In those days, I wasn't very good yet, and and was operating under the radar. Looking back, I now realize that I was simply copying famous artists, polishing my skills and techniques in the process, without any real foundations. The turning point was when I first tried to copy photographs. Struggling with that taught me the importance of learning the basics. After that, I paid closer attention to the structure of actual objects and perspectival composition. Slowly but surely, I thereby established my own style.

Q. Work always involves stress. What has produced stress for you, and how have you handled those times when you felt down?

When I first turned professional, I lacked experience and was unable to manage my time properly. That was my main source of stress. It was harder to draw in

プロになって最初の頃は、経験が足りないので時間に追われていることが一番ストレスになります。それに描きづらさも感じるし、締め切り通り提出できるかも心配でした。この依頼が終わったら次が来ないんじゃないか、なども怖がってましたね。でも経験を積んで、レベルも上がったら、その心配は段々少なくなって。今になって言える話ですが、トラブルも何もなくてとても感謝しています。もう一つどうしても抜け出せないストレスは、絵の劣化への恐怖かもしれません。完成した絵があまり評判が良くなかったとか、自分が見てもこれはダメだな（でも、どこがダメのかはっきりわからない）とか、そんな時はやっぱり落ち込むんですよ。でも日が経って、またもう一度前の絵を見たら、どこが足りないかがわかるかもしれない。満足できない絵を描いたのは絵が劣化したからではなく、自分の知識が及ばない領域に入ったからかもしれない。画力が下がった訳ではないけど、短所が目立つので、全体の絵の感覚に影響が出る。後で短所が見えるようになったら、逆に練習の成果が出ているということだと思います！

絵のレベルの向上に必要なのは
「時間」「モチベーション」「勉強の仕方」

——デジタルで絵を描くようになったのはいつ頃からですか？
最初は裏紙に鉛筆で描いていて、アナログで描くことを半年くらい続けてから、タブレットに乗り換えました。理由は色を塗りたかったから。家は幼児用の色鉛筆しかなかったので、それではやはり描けないと思って、Wacom Intuos Pen & Touch small を購入しました。ソフトは最初は Easy Paint Tool SAI でした。

——今は何を使っていますか？
タブレットは、実はまだ Wacom Intuos Pen & Touch small を使っています（笑）。ソフトは Photoshop CC にしました。27インチの Wacom Cintiq のディスプレイ付きのタブレットを使ってみたんですけど、結局慣れませんでしたね。手元を見ながら描くから首が痛いのと、かなり作業台のスペースを取るので、普段絵を描いてない時にパソコンを使ったら邪魔くさいのとで（笑）。最後は初心のスモールサイズに戻りました。僕の場合は、ディスプレイとタブレットを分けたほうが楽に感じます。

——絵の技術はどのようにして磨かれていますか？
僕は絵のレベルを安定的に向上させるためには3つのポイントがあると思っています。それは「時間」と「モチベーション」と「勉強の仕方」です。

1「時間」
どの技術でも、上達するにはたくさんの時間と努力が必要です。「時間」はまずほとんどの人にとって、一つの高いハードルになると思います。僕みたいに元々美大生じゃない人の場合は、特に時間が足りないと感じるかもしれないですね。それもあって僕は大学1年生の時に中退しようと決めたんです。

those early days, and I worried whether I would meet my deadlines. I also feared that I wouldn't receive any more commissions after the current one was over. With experience and an increase in skill, however, those concerns diminished. Now that I have reached this point, I am so grateful that I never experienced any major problems. One other constant worry was that my artwork might deteriorate. The times that got me down were when a completed work was not well received, or when I knew it wasn't up to par, but could not identify why. Yet later, when I looked back at those works, I was sometimes able to spot what was wrong. I realized that it wasn't that my skill had dropped, but that I had attempted to advance into an area in which I did not yet have expertise. In those works, even though my skill was not at fault, specific weak spots negatively impacted the overall picture. Being able to later identify those flaws was a sign that practice had paid off!

The key to artistic improvement:
time, motivation, and proper study habits

Q. When did you become a digital illustrator?
In the beginning, I did pencil sketches on the back of scrap paper. After about half a year of such analog work, I switched over to a tablet because I wished to be able to easily use colors. We only had colored pencils for small children at home. I felt that was insufficient, so I got a Wacom Intuos Pen and Touch Small Tablet, using Easy Paint Tool SAI software initially.

Q. And what do you use now?
Actually, I still use the Wacom Intuos Pen and Touch Small Tablet (laughter). For software, I switched up to Photoshop CC. I tried using a tablet with a 27 inch Wacom Cintiq display, but I never could get used to it. I had to look down as I drew, and that made my neck hurt, and it took up so much space that it got in my way when I was just using my computer (laughter). I ended up going back to the smaller version for beginners. I found it more comfortable to separate the display and the tablet.

Q. How do you hone your artistic skills?
For me, steady improvement comes from three components: time, motivation, and proper study habits.

1. Time
Improvement of any skill requires considerable time and effort. Time is surely a challenging hurdle for most people. You might say that for somebody like me who wasn't an art student, time was a particularly big issue. In fact, that is one of the reasons I decided to leave college when I was a freshman. After that, I devoted all of my time to drawing. I recently gathered old works for a personal

GUWEIZ 氏の作業環境　GUWEIZ's work environment

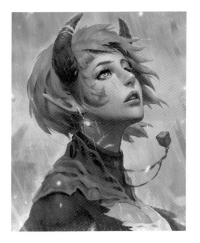

試しにピアスの光源を入れ始めた頃の作品。その後の
ターニングポイントになった。
One of GUWEIZ's early works featuring an earring
as a light source, a turning point for the artist.

それからは絵を描くことにすべての時間をかけました。最近、個人画集のた
めに過去の絵を集めていたんですが、それを見てみると、中退してからは絵
のレベルがものすごく上がったんです。その頃は1日12〜14時間くらい描
いてました。目覚めている限り描いているって感じです。本気で絵を仕事に
したい方は、まず練習の時間を確保したほうがいいと思います。

2「モチベーション」

時間はあったとして、心からモチベーションが湧かないと、毎日十何時間も
絵を描く生活は続かないですね。じゃあ、モチベーションをどう高めればい
いか。これは人それぞれです。僕の場合は、自分の進化を見たい気持ちがあっ
て、もっときれいな、魅力的な、注目されそうな作品を作りたいと思っています。
僕はゲームをするのと映画を見るのが大好きで、すぐきれいな背景や構図に
目がいく。あと普段はよくPinterestと花瓣（huaban.com）を参考にしてい
て、頭の中にいつもたくさんのアイデアが湧いてきます。何を描けばいいか
わからないことで描くことに落ち込む方もいるかもしれません。僕も、色々
資料を見ないと、ずっと一つの絵を描いてる時は何かに囲まれて進めない感
じがします。次の絵どうするんだろうって。困った時は、たくさんの資料を吸
収して、自分の興味のあるものを見つけます。

3「勉強の仕方」

最後に、正しい勉強のスキルとプランも欠かせないと思います。どうすればレ
ベルを効果的に上げられるか。これもやはり「人それぞれ」です。自分の興
味に合った練習システムで色々調整する必要があると思います。僕の場合は、
自分のオリジナルで設定を決めて練習をします。例えば、見下ろすアングルで
の背景構成を練習したい時、似たような角度の参考図を模写するより、自分
の好きな光・演出・人物で絵を構成する練習をしています。一番効果が出る
練習は、見下ろすアングルのレンズを想定した上で、できるだけパースと構造
を正確に描くことです。練習の内容以外に、練習・作業・資料収集の時間割
を決めることも大事なことです。仮に1年の中に、絵に関わる時間は3600
時間あるとして、この時間をどう使うか。いい本といいセミナーがあったら、
一部の時間（例えば500-1000時間）をこれに使って知識を増やすのもいい。
参考資料を収集する時間も必ず作らないといけない（例えば200-300時
間）。残りの時間は全部絵を描くことに使っていいでしょう。3600時間は多い
と感じるかもしれませんが、それは毎日平均約10時間が使える場合の話です。

collection, and found that once I left school, my level improved dramatically.
I was spending 12-14 hours per day on my art then. I feel like I was drawing
during every waking hour. Those truly committed to becoming an artist should
set aside sufficient practice time before anything else.

2. Motivation

Even if you set aside the time, I don't think you can continue drawing for 10 hours
each day unless you are filled with motivation from deep in your heart. How
do you increase your motivation? Well, it varies from one individual to another.
In my case, I'm dying to see personal progress, and I'm motivated to produce
works which are increasingly beautiful, fascinating, and irresistible to others. I
love playing video games and watching movies, and I instantly notice beautiful
backgrounds and compositions. I often reference Pinterest and huaban.com,
and my head is always full of new ideas. Some people may become depressed if
they cannot zero in on a subject to draw. If don't keep my mind fresh with lots of
new materials and ideas, I continue to draw the same picture for too long. I feel
trapped and unable to progress. I can't decide what to draw next. The thing to
do when you hit a wall is to absorb as much material as you can and find what
piques your interest.

3. Study Habits

Finally, good study skills and a clear-cut plan are indispensable. How can you
effectively raise your artistic level? Everyone is different, of course. Each person
needs to fine-tune their own system to meet their own tastes. In my case, I cre-
ated my own original style. For example, if I wish to practice drawing background
scenery looking downward from an elevated position, I create my own compo-
sition with its own characters, lighting, and action, rather than referencing and
copying a similar existing work. The most effective result comes from imagining
a scene viewed through a lens from an overhead angle and trying to get the
perspective and structure right as I draw. It's also important to decide what
percentage of your total time to allocate to practice, work, and data gathering.
Let's say you plan to spend 3,600 hours on your art during a given year. How will
you break that down? If you have access to worthwhile books and seminars, you
could spend—let's say—500 to 1,000 hours absorbing them, enhancing your

時間は少ないほど、大事に管理しなければならないと思います。

作風は基礎と経験の
結晶

──ご自身の作風についてどのように考えていますか?

僕は、作風というものは、実物の構造や基礎をしっかり勉強して、長い人生経験を積み、絵を描いてきた結晶だと思います。新しい事に触れ続けるからこそ、自然とより美しい作品とより独特な作風が作れます。こう考えれば、自分の作風ができないことを怖がる必要はないと思います。

──作風が定着していくきっかけはなんでしょうか? 何か影響を受けたものはありますか?

作風はやはり基礎が大事だと思います。建物を建てる時の基礎と同じ話なので、基礎が不安定であれば、一定の作風が発揮できない。この基礎も定期点検が必要で、表面的な特徴にこだわりすぎて基本を忘れたら、自分だけの作風を築くのは大変かもしれません。

──GUWEIZさんが描くキャラクターは、闘っているか冒険の最中の女性のイメージがあります。こういった絵を多く描いている理由は何かありますか?

自分の観察だと、女性キャラクターを描いている作家さんは多いような気がします。絵も一つの模索だと思っています。僕の場合、大体のキャラクターデザインのアイデアは、全体の構図に合わせて調整している感覚でやっているんですけど、最近になって、人物の設計に集中するようになってきました。ラフから完成までのプロセスで一番大事に思ったことは、やはり次のために経験を積むことですね。

──「光るピアスをつけた少女」を特徴とするイラストはすでにシリーズになりましたね。ピアスには何か特別な意味が込められていますか?

この特徴を作った最初の一枚の時は、とりあえず絵の中に一つポイントを作りたいと思っていました。僕の絵は暗いシーンが多いので、見た人にコントラストが弱いイメージを残したくなくて、このピアスで目立つ光源を入れようとしました。深い意味は思いつきませんが、ミステリアスな感じを出したいという希望はありました。

自分の絵をいいね数稼ぎのゲームにしない
いい絵を描けば人は集まってくれる

──いつ頃からSNSをスタートしましたか?

絵を描き始めた時(2012-13年)に、もうDeviantArtを使ってましたね。Instagram, Facebook, Twitter, ArtStationはその後でした。

──SNSの管理についてご自身の考えはありますか?

そうですね。現代のネット世界はものすごく発展していて、使いやすいし、効果的だと思っていますよ。でも夢中になり過ぎて、自分の絵をいいね数稼ぎのゲームにしないように気をつけなければいけない。僕にとっては、SNSはあくまで作品をアップロードして、たまにシェアをしてくれた方に感謝を伝え、自分の好きな画家や写真家をフォローするところですね。管理のポイントとかは特にないかな。頑張っていい絵を描く! くらいです。そうすれば自然に見る人が集まってくれます。

──今の時代、SNS運営やネットの力は、プロのイラストレーターにとってどのような意義がありますか?

すごく強い力になっていると思います。特に近年は、ゲーム・映画制作会社が大体ネットから依頼先をスカウトするので、さらにネットの重要性が増しましたね。同時に、自分の作風を認めてくれる観客を十分に集められれば、自分で画集を出してもいい。法人のクライアントに依存しなくても大丈夫です。

expertise. You should also dedicate some time to collecting reference materials (say 200-300 hours). You are then free to use the remaining hours drawing. The 3,600 hours may sound like a lot, but it averages out to 10 hours per day. The less time you have, the more important it is to manage it properly.

Style: the crystallization of the basics and experience

Q. How do you see your own style?

I think style is the crystallization of the study of the structure of things and artistic basics, combined with years of life experience, within a work of art. Continuing to experience new things has naturally enhanced the beauty of my work and the uniqueness of my style. If you think about the matter in this way, you never have to fear about not developing your own style.

Q. What made you realize you had achieved a personal style? Was there something in particular that influenced you?

You must have a firm foundation in order to develop a personal style. It's no different from the importance of a solid foundation for a building. Artists need to periodically go back and refamiliarize themselves with the basics. It is difficult to establish a distinctive style if you forget the basics and focus only on surface features.

Q. The characters you draw are often females engaged in battle. Why do you focus on this subject matter?

From what I can tell, many artists draw female characters. I believe that drawing is a type of quest. In my case, my ideas about character design have tended to stem from the overall composition of the piece. Recently, though, I have begun focusing more on individual character design. I have always felt that, during the process from rough draft to final work, the most important thing is gaining experience which will help me in my next project.

Q. Your illustrations featuring a "girl with glowing earrings" is now a series. Do the earrings have any special meaning?

I simply sought a specific focal point when I created the first work in this series. As most of my pictures feature dark scenes, I added the earrings as contrast, as a light source to strengthen the overall image. There is no deep meaning to them, but I did want to create a more mysterious feeling.

I don't concern myself with "likes," since great pictures find their own audience

Q. When did you become active on social media?

I became active on DeviantArt almost from the moment I began drawing (2012-2013). My Instagram, Facebook, Twitter, and ArtStation presence came later.

Q. Do you have a policy about social media management?

Let's see... the online community has developed enormously. It's easy to access, and really effective. However, one must be careful not to get too swept up in the game of trying to win as many "likes" as possible. My own level of participation is pretty much limited to uploading my works, occasionally thanking those who share them, and following my favorite artists and photographers. I don't have any particular words of wisdom about social media management. My advice is just to do your best and create great work! If you do that, you will naturally gain fans.

Q. What significance do social media and the power of the Internet have for professional illustrators in today's world?

Both are incredibly powerful, I think. Nowadays, most video game and movie

──初作品集「Guweiz: The Art of Gu Zheng Wei」もクラウドファンディングで宣伝し予約販売を行っていましたね。何かシェアしたいことなどありますか？
応援してくださった皆様本当にありがとうございます。この度は3dtotalと画集を出版できたこと、予想していたよりもたくさんの方に関心をお持ちいただけたことに本当に感謝の気持ちでいっぱいです。元々は、この一冊で今まで見守ってくれていた方々に、自分が絵を描いてきた軌跡や過程にあったチャレンジ、僕の絵の完成までのプロセスを見せたいと考えて作りました。本についてもっと詳しく知りたい、または購入を検討されている方はぜひこちらのリンクまでアクセスしてご覧になっていただけると幸いです。まだ英語のみになりますがよろしくお願いします。
https://shop.3dtotal.com/books/guweiz

アジアのイラストレーターに懐かしさを感じる

──アジアのイラストレーターについて、どのようなイメージがありますか？
最近気づいたことなんですけど、僕、結構アジア出身のイラストレーターさんやデザイナーさんをフォローしてます！なんか皆のその雰囲気的な部分が好きなのかもしれないです。アジア人なら生活や習慣に共通点は多少あるんですかね。なんとなく懐かしく感じます。

──特に注目している作家さんはいますか？
皆様ぜひZeen Chin氏を見てください！！

──最後に、今後の展望についてお聞かせください。
いま全世界がコロナウイルスと闘っている中、絵を仕事として続けられるだけでもう十分幸せだと思います（皆様のお手元にこの本が届いた時、事態が鎮静化していることを心から祈っております）。技術面の目標として、これからも練習と模索を続けて、更に基礎を強くして、将来もっといい絵を描けたらと思います。仕事面では、今後も皆様のお力添えも頂きながら、また画集出版もできて、自分が創った人物や幻想的な世界をもっと発信できたら嬉しく思います。

──本当にありがとうございました。
今後ともどうぞよろしくお願い申し上げます。

プロフィール
GUWEIZ
1995年上海生まれのシンガポールアーティスト。高校から本格的に絵を描き始め、大学1年の時にプロの道に進む。2020年に初作品集『Guweiz: The Art of Gu Zheng Wei』（3dtotal Publishing）を出版。

夢蝶 MUCHO
1993年中国新疆生まれ、神奈川在住。多摩美術大学卒。イラストレーター / 著作権エージェント / 日中翻訳者 / キュレーター。中華圏作家の日本活動や日本作家の中華圏活動を支援している。
https://www.mucho-gallery.com/

初作品集「Guweiz: The Art of Gu Zheng Wei」3dtotal Publishing / 2020
Guwiez's first published collection of works: *Guweiz: The Art of Gu Zheng Wei*, published by 3dtotal Publishing, 2020

companies scout for artists online, making the internet more important than ever. Meanwhile, if you can bring together enough fans interested in your style, you can publish your own collection of works. Then you won't have to depend on corporate clients.

Q. Your first collection of works, *Guweiz: The Art of Gu Zheng Wei,* **was promoted via crowdfunding and sold through advanced orders. Is there something you wish to tell us about that?**
I would like to thank all those who supported me. The interest shown in my collection of works created with 3dtotal exceeded my expectations, and I am so appreciative to everyone for this positive response. My intent was to create a single volume for all those who have followed me, so they could grasp the evolution of my work, the challenges I met, and the process from start to finish. The following link may be of interest to those wishing to learn more or considering purchasing a volume. Only the English version is available at present.
https://shop.3dtotal.com/books/guweiz

Works of Asian illustrators always make me feel nostalgic.

Q. What is your image of Asian illustrators?
I recently noticed that I'm following lots of Asian illustrators and designers. It may be that I like the atmosphere they all have in common. Asians have similar lifestyles and customs. There is something nostalgic about their work.

Q. Is there any particular artist who stands out for you?
I hope everybody will check out Zeen Chin!

Q. Finally, would you share your future aspirations with us?
With the entire world battling the coronavirus, I am extremely happy just to be able to continue drawing (and I hope the situation will have improved by the time this book reaches its readers). On the technical side, I hope to continue training and exploring, strengthening my command of the basics to produce even better works going forward. On the work front, with everyone's support, I hope to publish another collection of works and continue sharing my characters and magical worlds.

Q. Thank you for this interview.
Thank you so much for this opportunity.

Profile
GUWEIZ
Born in Shanghai in 1995, Singaporean artist GUWEIZ started drawing seriously during high school, and left university after one year to pursue life as a professional artist. He published his first collection of works, *"Guweiz: The Art of Gu Zheng Wei,"* in 2020 with 3dtotal Publishing.

MUCHO
Born in Xinjiang, China, in 1993, MUCHO now lives in Kanagawa, Japan. A Tama Art University graduate, MUCHO pursues the multiple roles of illustrator, copyright agent, Japanese-Chinese translator, and curator. She supports the activities of Chinese artists in Japan, and those of Japanese artists throughout Greater China.
https://www.mucho-gallery.com/

ASIAN ILLUSTRATION
アジアンイラストレーション

2020 年 9 月 10 日 初版第 1 刷発行
2022 年 1 月 20 日　　　第 3 刷発行

編著
パイ インターナショナル

カバーイラスト
GUWEIZ

装丁デザイン
名和田耕平デザイン事務所

本文デザイン
松村大輔 / 佐藤美穂（PIE Graphics）

英文翻訳
末永直大　＊p146-149 作品内英訳
Marian Kinoshita & Stephanie Cook

編集協力
AMANN CO., LTD.
九層塔
末永脩人
ねこまた工房
韓 幸子
Miki Liu
夢蝶（上海摩都文化 / 上海 COMICUP）
Ryan Holmberg

協力
アジア出版文化振興協会
樂藝 ArtPage
黒木黒木
杭州森雨文化

編集
中村 愛

発行人
三芳寛要

発行元
株式会社 パイ インターナショナル
〒 170-0005　東京都豊島区南大塚 2-32-4
TEL 03-3944-3981　FAX 03-5395-4830
sales@pie.co.jp

印刷・製本
シナノ印刷株式会社

©2020　PIE International
ISBN978-4-7562-5371-2 C0079
Printed in Japan